STREET ART ACTIVITY BOOK

RECLAIM THE STREETS
FROM THE COMFORT OF HOME

An Hachette UK Company
www.hachette.co.uk

First published in Great Britain in 2018 by Mitchell Beazley,
a division of Octopus Publishing Group Ltd
Carmelite House
50 Victoria Embankment
London EC4Y 0DZ
www.octopusbooks.co.uk
www.octopusbooksusa.com

Originally published in the French language under the title
Street Art – Cahier d'activités © Tana Éditions, an imprint of Édi8, 2016

English language translation copyright © Octopus Publishing Group Ltd 2018

Distributed in the US by Hachette Book Group
1290 Avenue of the Americas
4th and 5th Floors
New York, NY 10104

Distributed in Canada by Canadian Manda Group
664 Annette St.
Toronto, Ontario, Canada M6S 2C8

ISBN 978-1-78472-322-4

A CIP catalogue record for this book is available from the British Library.

Printed and bound in Slovenia

10 9 8 7 6 5 4 3 2 1

STREET ART ACTIVITY BOOK

RECLAIM THE STREETS FROM THE COMFORT OF HOME

MITCHELL BEAZLEY

CONTENTS

OAK OAK

IN TUNE WITH THE CITY

"WHAT INTERESTS ME IS WHAT HAPPENS BY ACCIDENT," says Oak Oak (pronounced "Wak-Wak"), an artist who has made redesigning cities into a daily exercise. He works on walls, of course, but also on bus shelters, advertising hoardings, lamp posts and pedestrian crossings. Nothing escapes his sharp eye, which transforms every odd crevice into a story. "It's always the place that shapes the idea," he explains. A post on a street corner looked a bit like the Empire State Building, so he stuck a paper King Kong and a few aircraft on it. The shadow of a parking meter reminded him of a dog kennel, so there's Snoopy, asleep. And then there's Homer Simpson, Mario Bros, Yoda and other, nameless characters: Oak Oak borrows freely from multiple, eclectic worlds. "I grew up in the 1990s, on a diet of a certain kind of popular culture, including video games, and this sometimes crops up in my work. But they aren't deliberate references – more than anything I look for the image that best fits a given location."

However, he confesses to a soft spot for Calvin and Hobbes, whom he has used several times, and for the gentle, disturbing humour of their creator, Bill Watterson. Like Watterson, Oak Oak lets his imagination loose in everyday reality. He wanders the streets in search of the idea that will give a new dimension to a featureless place – tiny spots of brightness that constitute small victories on the grey city canvas. "I might pass a place near where I live dozens of times before suddenly realizing what I can make of it... Reconnaissance is an essential part of my work."

Oak Oak likes to play with things that pass almost unnoticed. Minimalism is his ideal. "If I could draw just two lines and create a character, that would be perfect! The less I make of something, the happier I am." So, on a crumbling bus shelter, he simply placed a sheet of paper bearing the words "Chuck Norris hates waiting for the bus." Next to the shattered glass of another: "Susan Boyle sang here." His home town of Saint-Étienne offers many sites that are derelict or awaiting development – the very spaces he likes best, and the ones that are most in need of being redesigned. "I find it harder to work in really beautiful historic sites, which are fine as they are and need nothing more..." In each new location he looks for the detail that would pass others by. "Street furniture differs greatly from one town to another, which means it yields infinite possibilities. For example, in some cities they have magnificent round-ended bollards that I've been able to transform into hats, including Charlie Chaplin's!"

Cities come to life beneath Oak Oak's inventive gaze. "If I can make people smile, I'm delighted – even though I don't necessarily think of passers-by when I create something." Those smiles may be playful, but they're not without a hint of menace. Many of his creatures are taking a tumble, looking battered or trapped behind the bars of a garbage container or ventilation grille... "My characters are often in a tight corner. But if there's no danger, there's no story!"

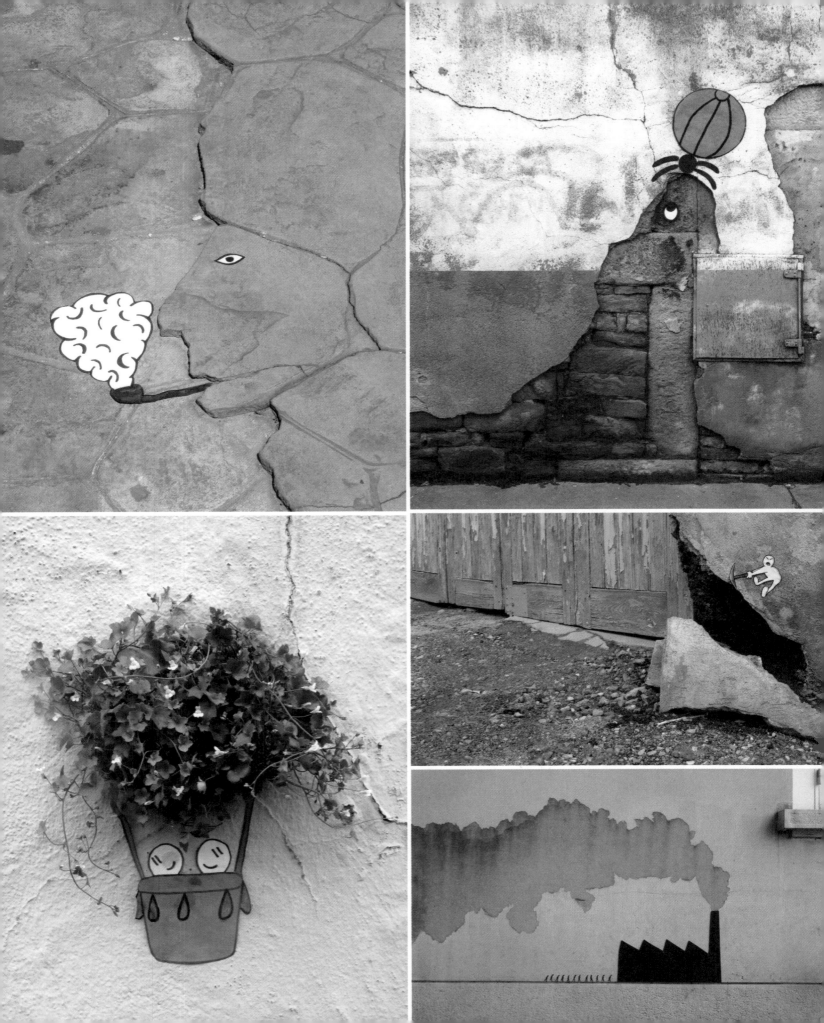

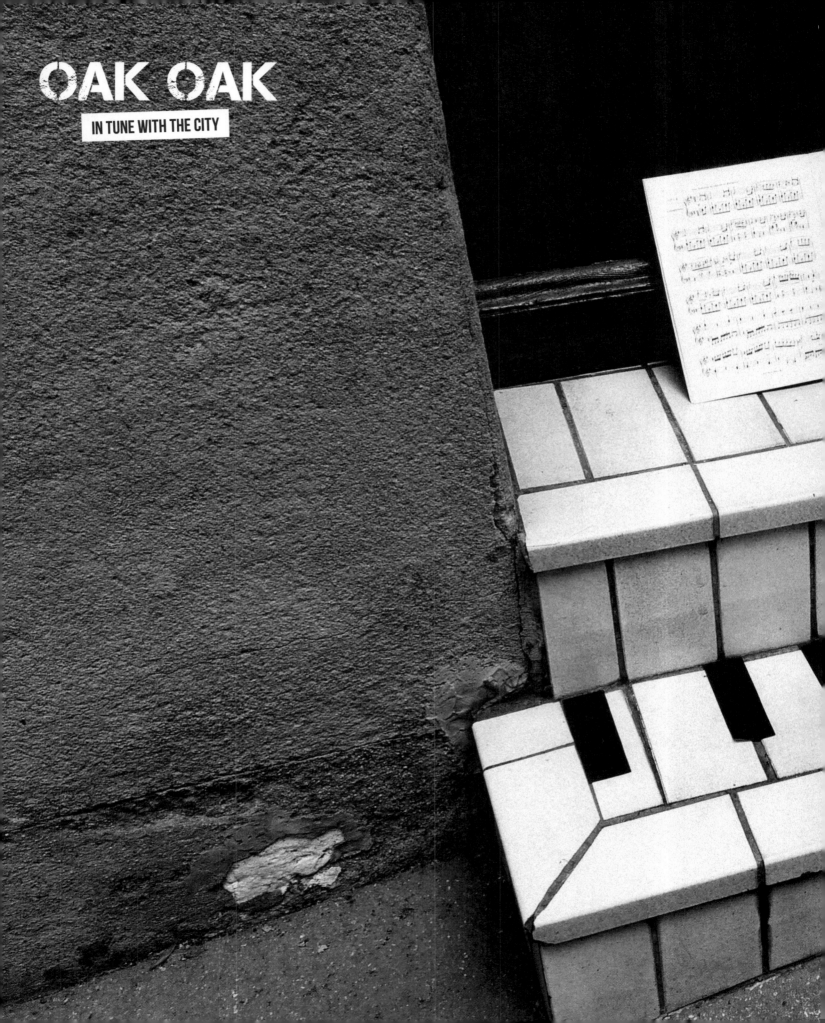

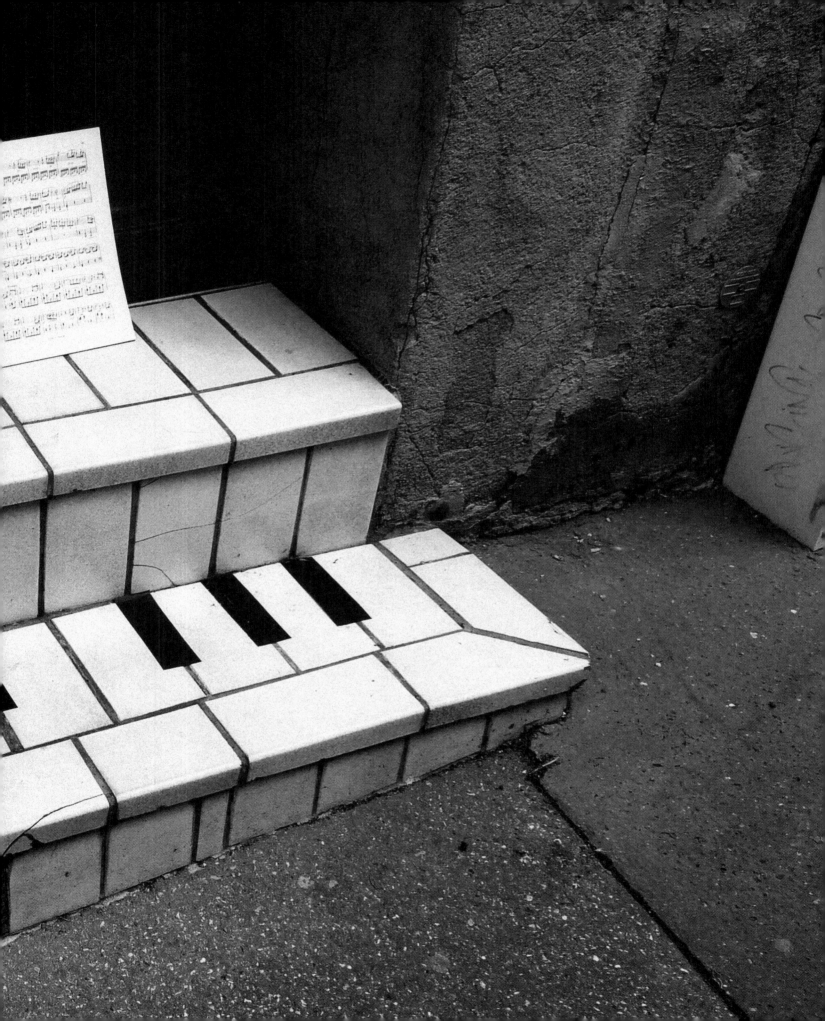

OAK OAK

EXPLOIT THE CITY'S SHAPES

OAK OAK

EXPLOIT THE CITY'S SHAPES

OAK OAK

EXPLOIT THE CITY'S SHAPES

OAK OAK

EXPLOIT THE CITY'S SHAPES

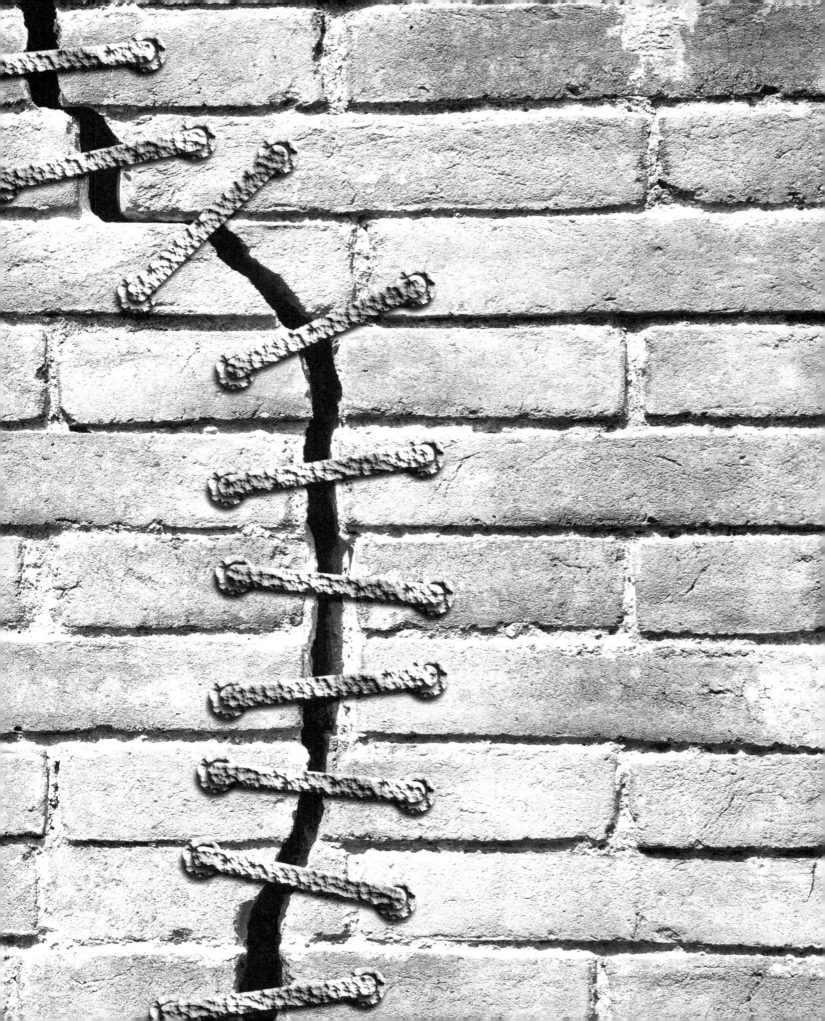

OAK OAK

EXPLOIT THE CITY'S SHAPES

LE CYKLOP

THE EYE IN THE STREET

A **SINGLE EYE,** in the round globe of a street bollard. This is the signature of the artist who goes by the name of Le CyKlop. "The cyclops is truly a universal character, found in many mythologies – Greek mythology, of course, in the *Odyssey*, but also Celtic and Japanese myths... It epitomizes the idea of the monster, which speaks to everyone."

Born in 1968, Le CyKlop moved to Paris at the end of the 1990s and began to draw cyclops in 2007. He worked in the street using stencils, and was influenced by the city's first stencil artists, Blek le Rat and Miss.Tic, whose work he admired. Then he began to exhibit. The first show was in 2010, when his work appeared alongside that of other well-known figures in the field, such as Gérard Zlotykamien, the VLP (Vive la Peinture – "Long Live Painting") group, L'Atlas and Jef Aérosol.

Le CyKlop is also inspired by gaming and manga, popular culture and explosive colours. "I really like flashy stuff," he says, smiling. In his world, square-topped bollards become pieces of Lego, straight out of childhood... Also a graphic designer, he champions the use of minimalist methods. "I love being able to bring a character to life using just a circle and a splash of paint. That means people looking at it also play their part in creating the story. I am often fascinated by what they see in my work." He has also worked on road signs, sometimes in order to create strange self-portraits. He likes subtle references to those close to him: *Lovers* is the title he gave to two bollards surrounded by hearts – an allusion to his partner and himself. And *Self-portrait with Roxane* is a sticker applied to the small human figure on a sign warning drivers of schoolchildren crossing. A playful distraction at the heart of the city, which he feels is essential. "What interests me is catching people's attention, bringing some joy into the street and opting out of restrictions. I want to ask questions about the way we live together. People talk about public space but, even though it belongs to everyone, no one takes possession of it for themselves. We need to take possession of the city again."

When he was starting out, Le CyKlop worked at night. Now he operates in broad daylight, having noticed the public's enthusiasm for his little creations. "People take great pride in street art. It allows them to enhance their environment. This became apparent when it was applied in the public, political sphere, as when huge frescoes were painted on buildings in Paris's 13th arrondissement." He is keen to share this militant approach: "I like to accomplish political acts in my everyday life." He has done this by holding numerous workshops, especially with children – which produced a series of monsters – and by paying homage to the world of cartoons and animation with his work in rue René-Goscinny in Paris, a street named after the writer of the *Astérix* comic books. "I think it's important to put a great deal of myself into my work," he explains.

Casting his fetishistic eye over objects, he follows in the footsteps of Keith Haring, whose generous, combative spirit he admires, with the aim of making art as a whole more democratic. Corkscrews, silk-screen printed wine bottles, candles, T-shirts – he uses a multitude of canvasses for his images, though these are always limited editions. "I'm very attached to the idea of interactive art objects that can be *used* – the original meaning of the word 'design'." For Le CyKlop, this is a logical extension of his urban explorations. "The traditional painter's canvas is finished. It's been done to death! If there is any unifying element in street art – and it's hard to discern one – it's the exploration of new canvasses."

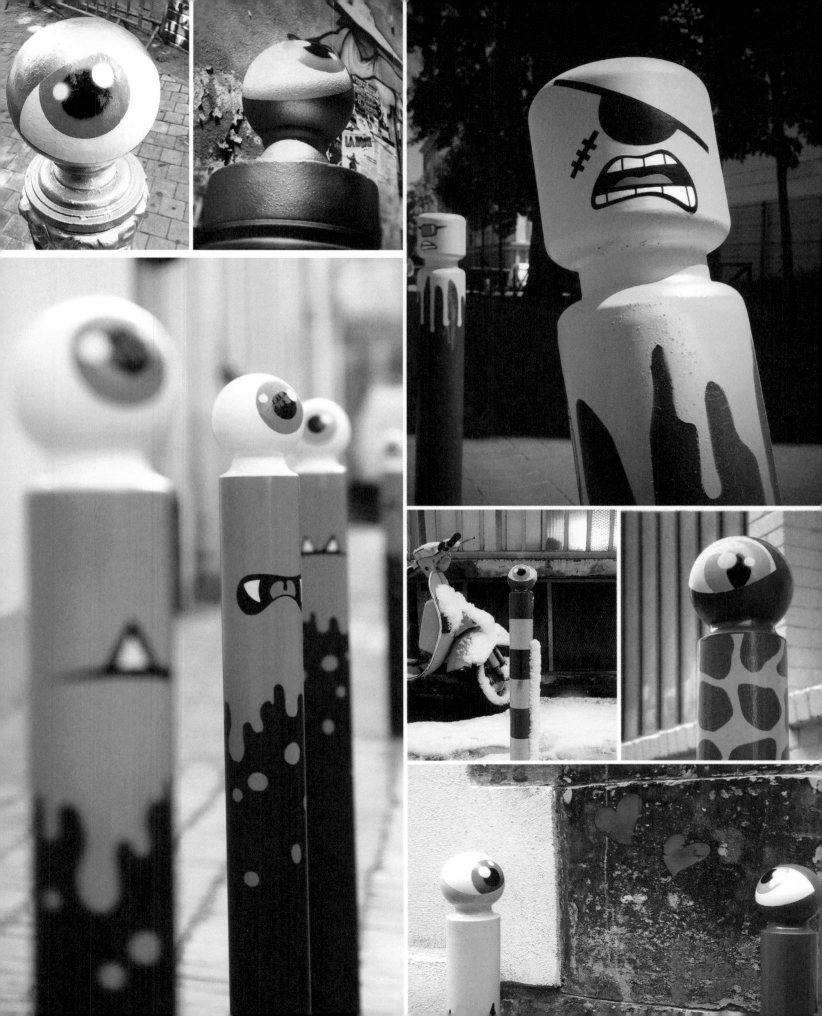

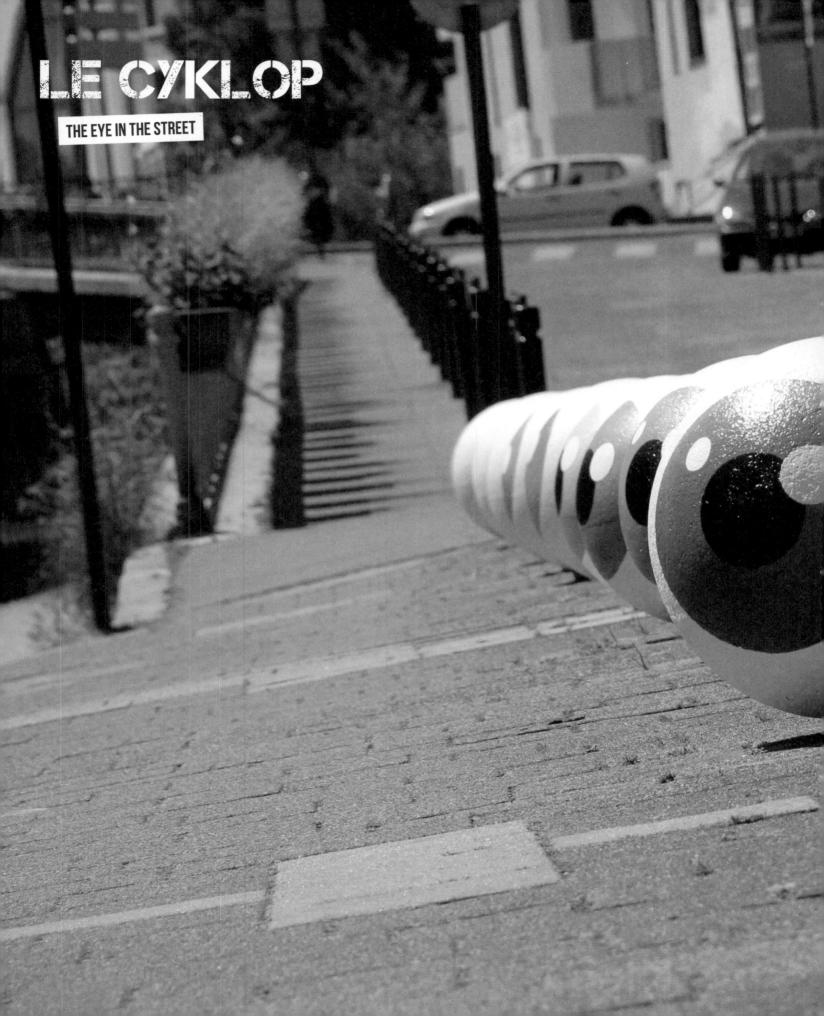

LE CYKLOP

THE EYE IN THE STREET

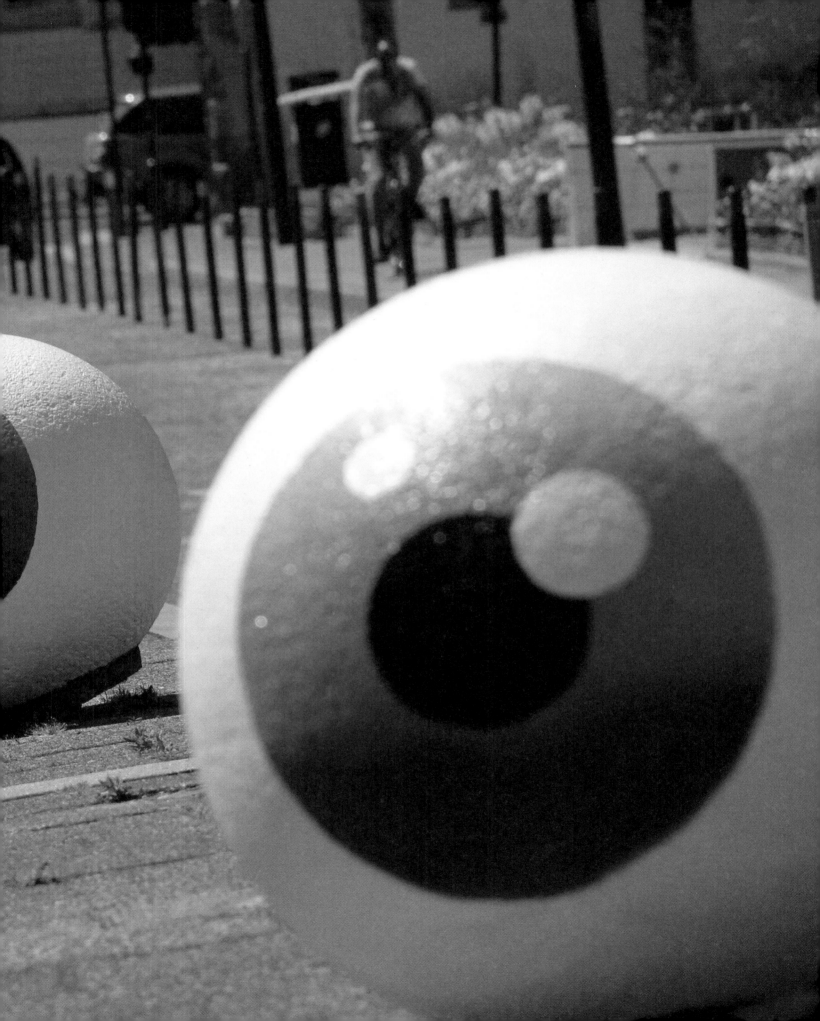

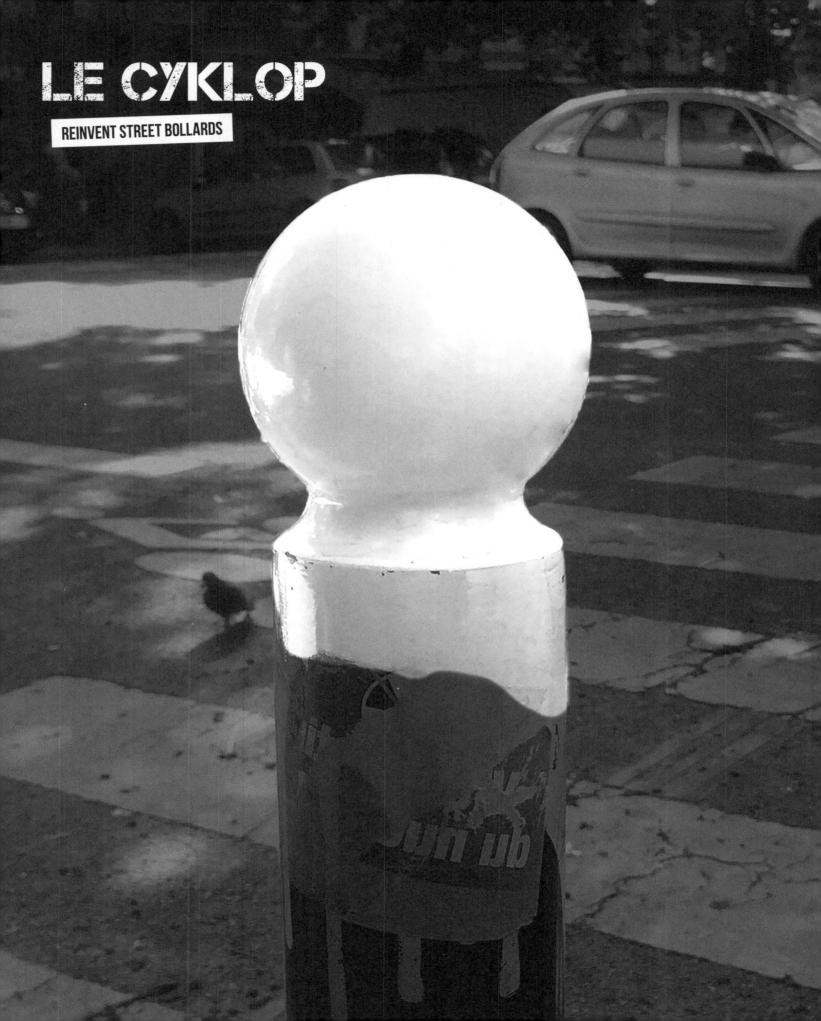

LE CYKLOP

REINVENT STREET BOLLARDS

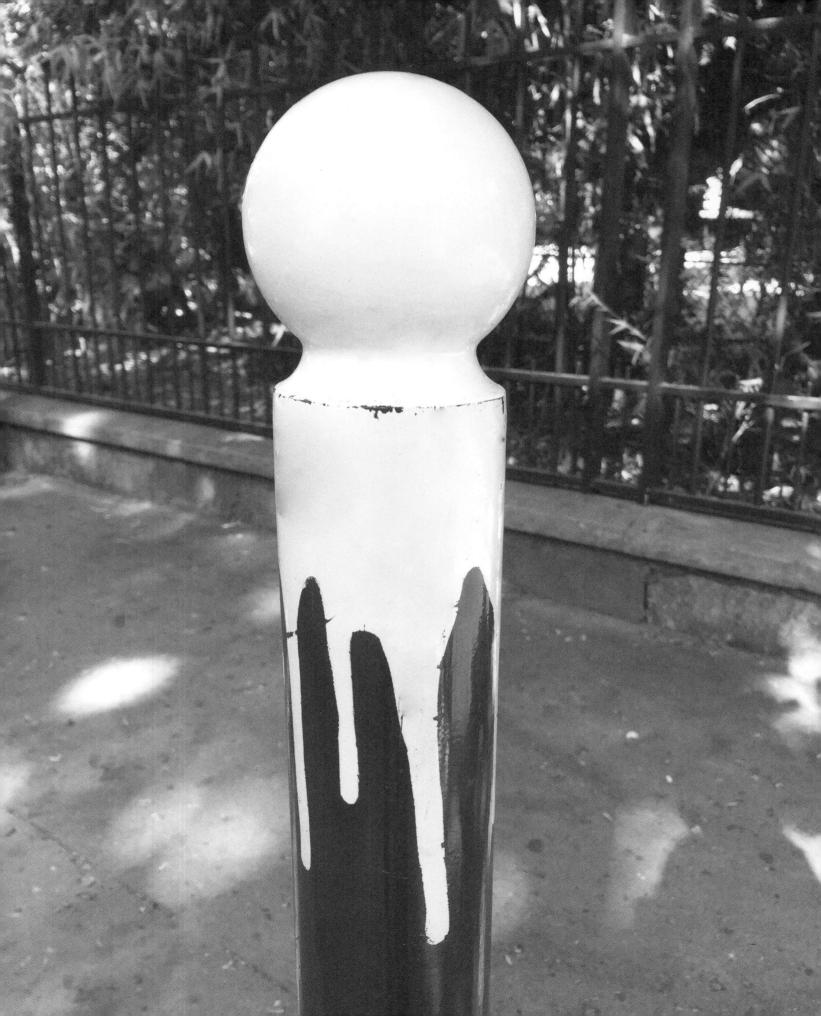

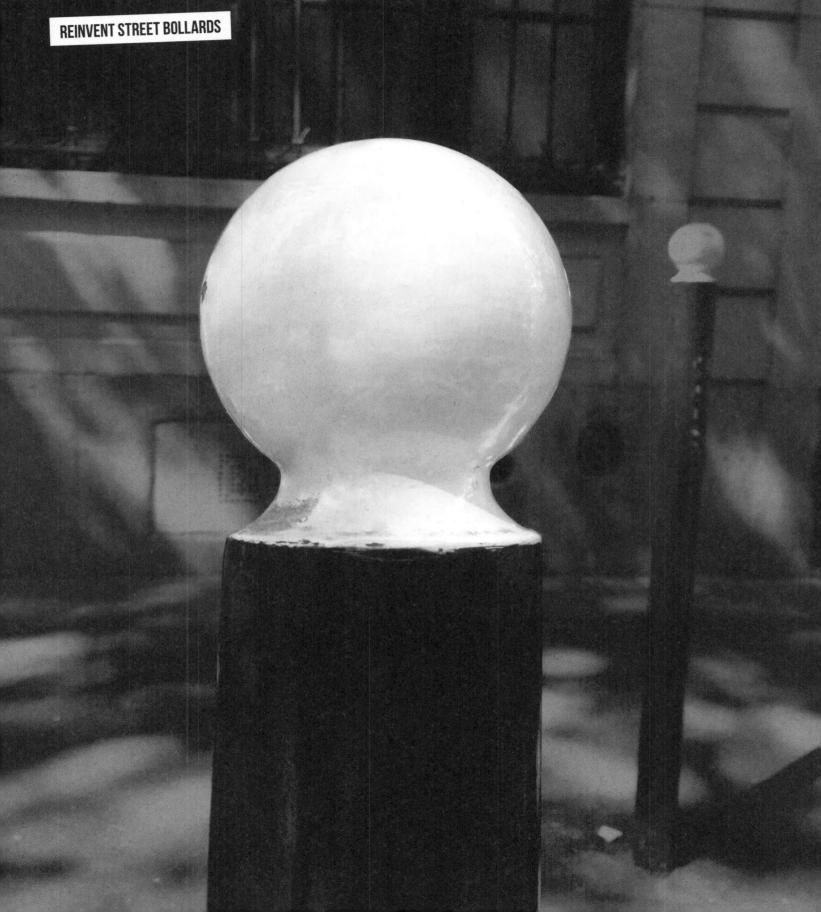

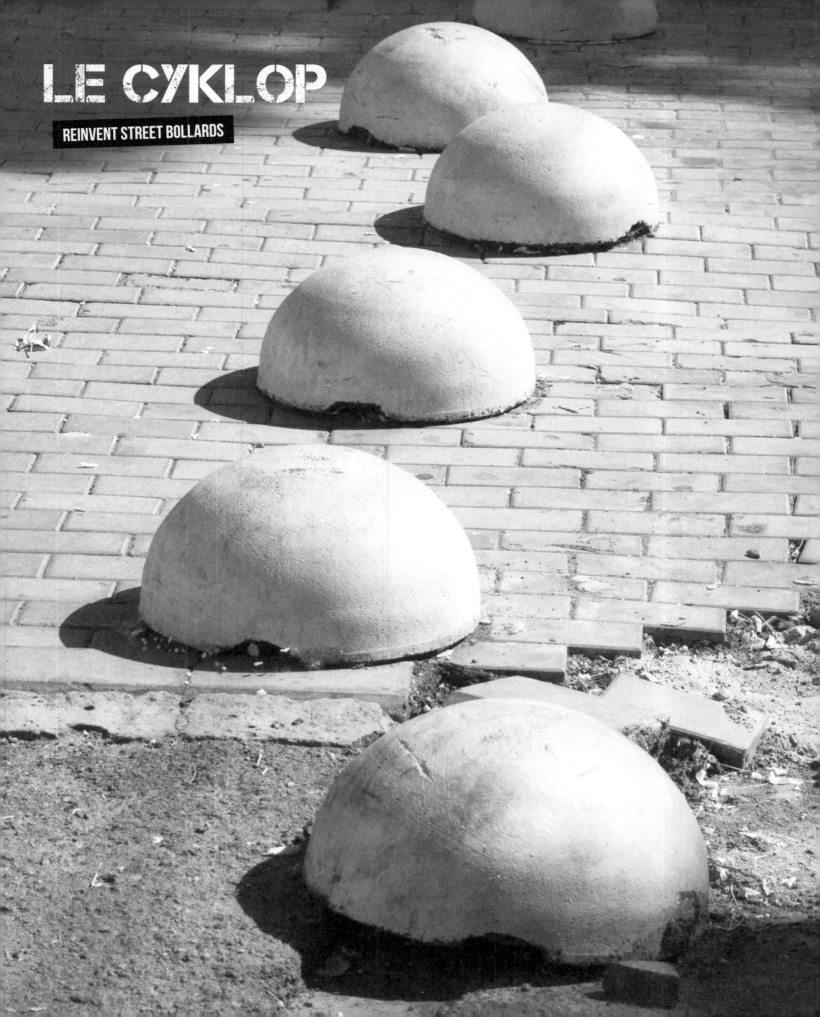

LE CYKLOP

LE CYKLOP

REINVENT STREET BOLLARDS

GIACO
AWAKENING THE CITY

DRAIN COVERS are windows that open on to the insides of the city. They have always fascinated Giaco, who used to imagine them as ribcages. One day, he took matters into his own hands and made a template to complete the skeleton, using an aerosol can. "This opening on to some apparently bottomless chasm seemed to me to have a parallel with the idea of death. And it felt as if I was finishing off the figure begun by the person who had designed the drain cover." He chose bright colours, however, as a nod toward the cheerful rather than the macabre. Giaco, who is of South American origin, loves the joyful relationship with death found in Mexican imagery, as well as the sense of mockery that is present in the medieval allegories known as *danses macabres* (dances of death). And he wants to make his mark without upsetting people. "I liked the paradox of doing something illegal and discreet at the same time."

This was in his early days, in the 2000s. "Then, street art didn't have the scope it has now, and what I was doing seemed odd to most people." Nevertheless, he persevered, and embarked on other projects. With two friends, he set up a collective called Tutti Frutti, with the aim of dressing street "furniture" – fountains, phone boxes, bollards and so forth – with bits of coloured paper, making them look almost like stained-glass windows. "We wanted to create visual elements, motionless fireworks," he recalls "and bring back the sense of wonder, liven up these objects that everyone passes by without paying any attention." And passers-by took them to heart. "People compared our paper to Post-it notes, and interpreted them as expressing something, like drawings or little notes... We weren't expecting that, and it was a really lovely surprise!"

Awakening the city is a key theme for Giaco. "It's a matter of bringing to life something that seems invisible. Giving an expression to shapes." He also seeks to defuse the anxiety caused by universal surveillance – by using humour. "The political climate at the time was one of paranoia. I had the impression that cameras and police had proliferated."

Now aged 35, Giaco is forging a career as a sculptor – under his real name, which he prefers to keep secret. He describes his own sculptures as "trash, pop, surrealist and academic", and aims to bring together the two aspects of his work. "I'm trying to eliminate the split between what I do in the workshop and what I do in the street." His goal is to put bas-reliefs he has made on to city walls. "I like the idea of making the link between art history and the really up-to-the-minute movement that is street art. It would be a joy to get street art more recognized, and to silence those who still think of it as vandalism."

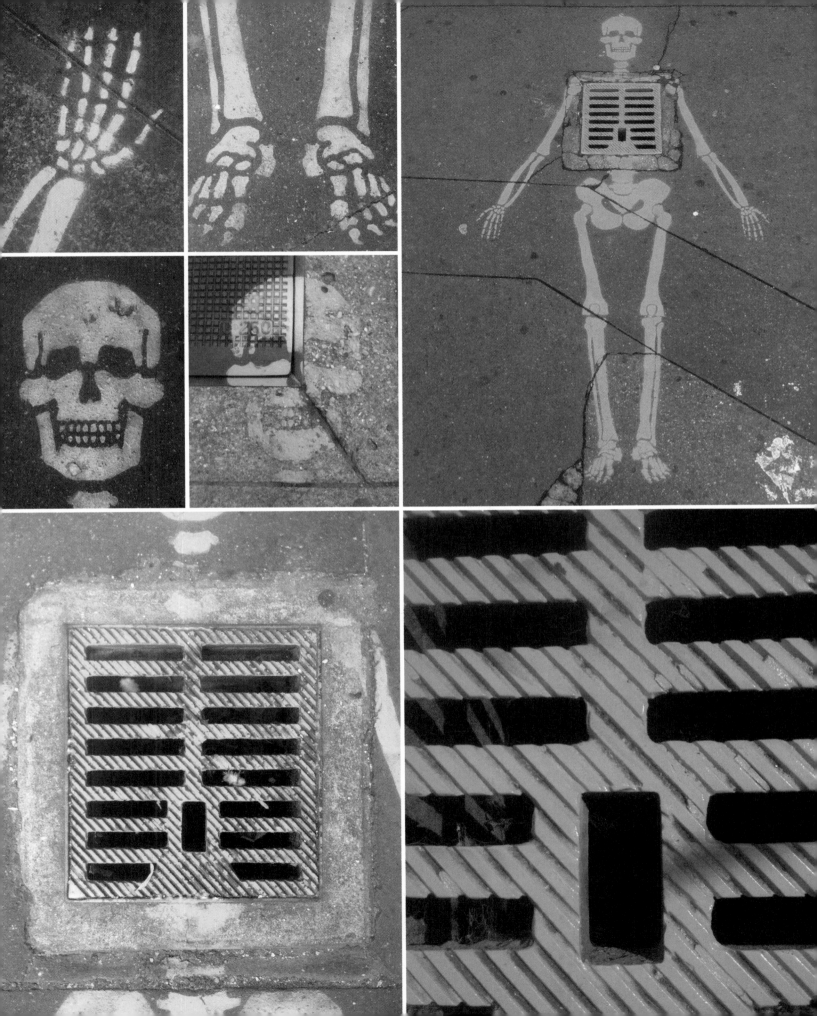

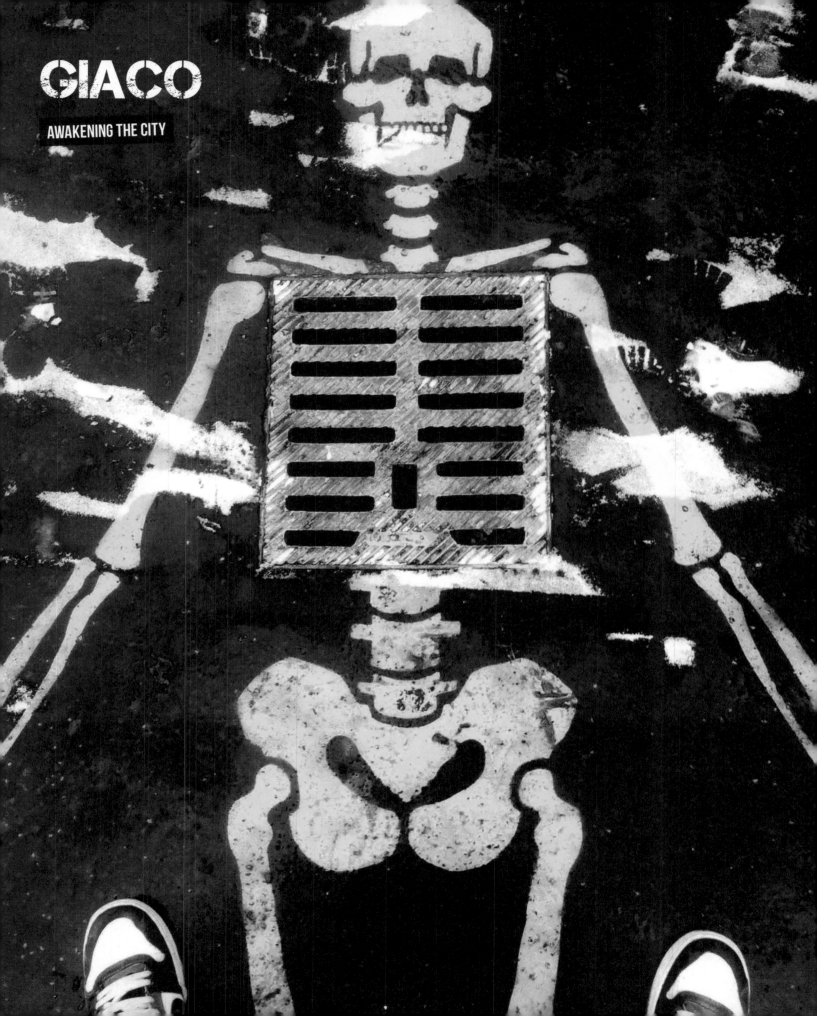

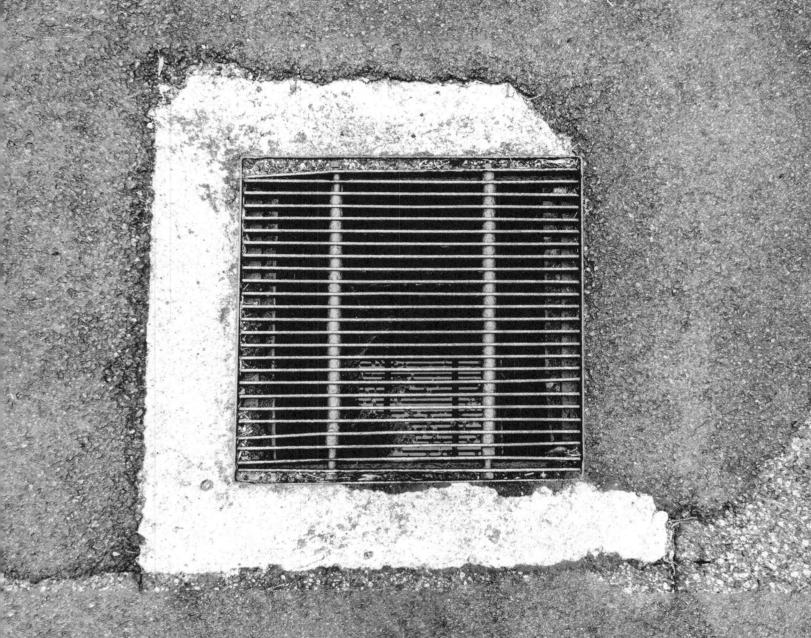

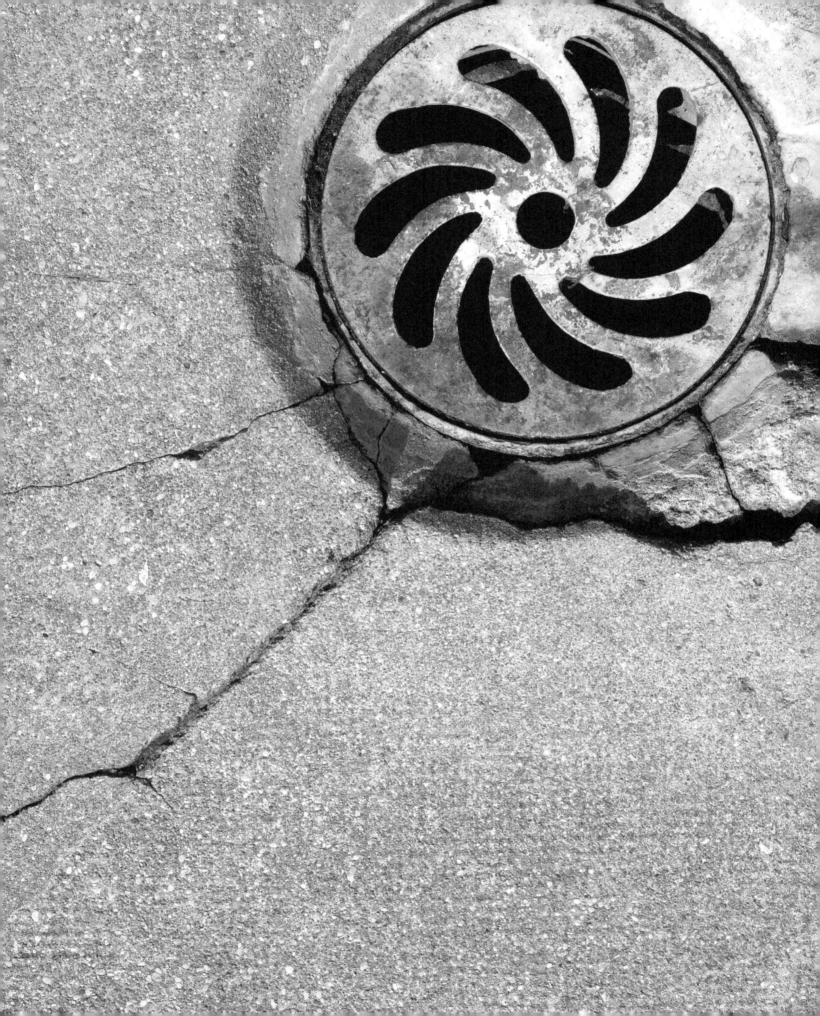

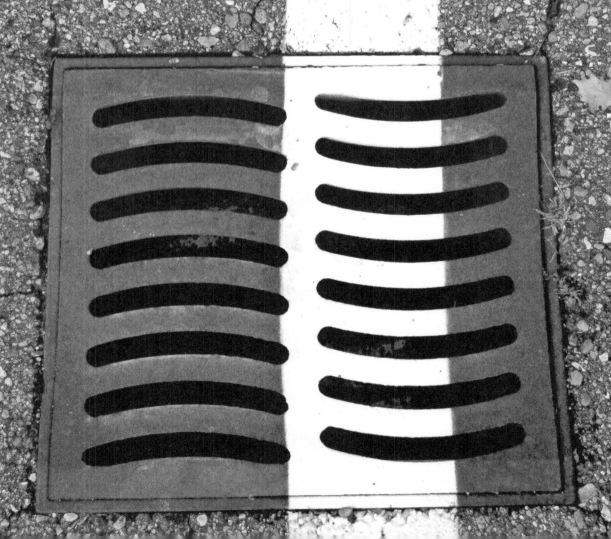

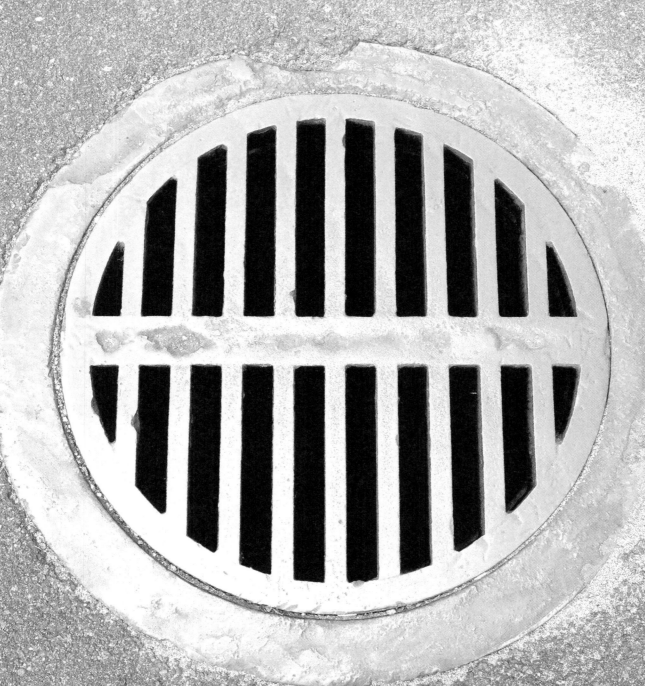

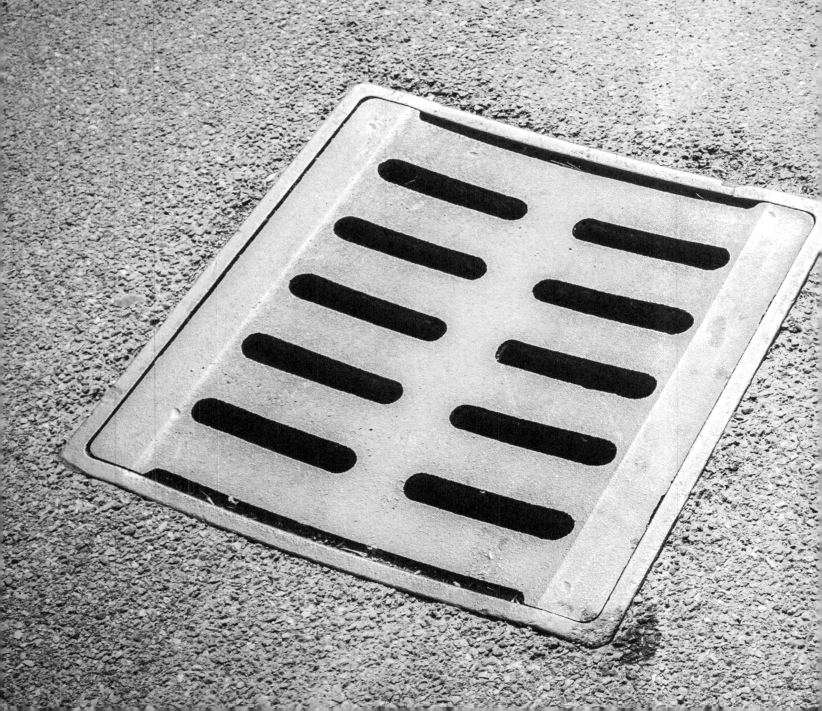

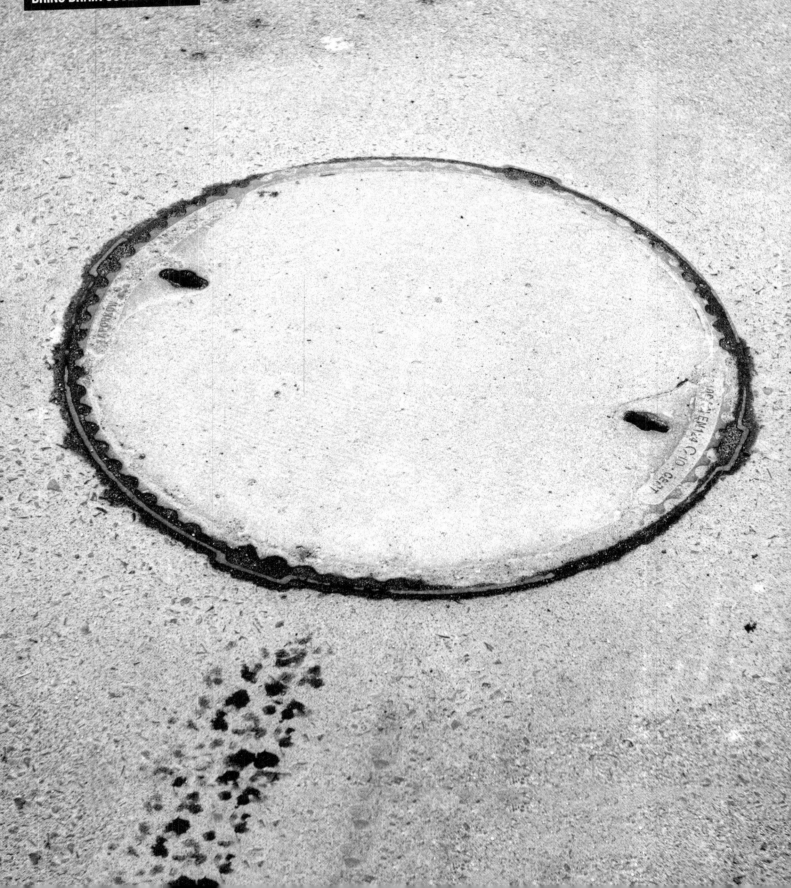

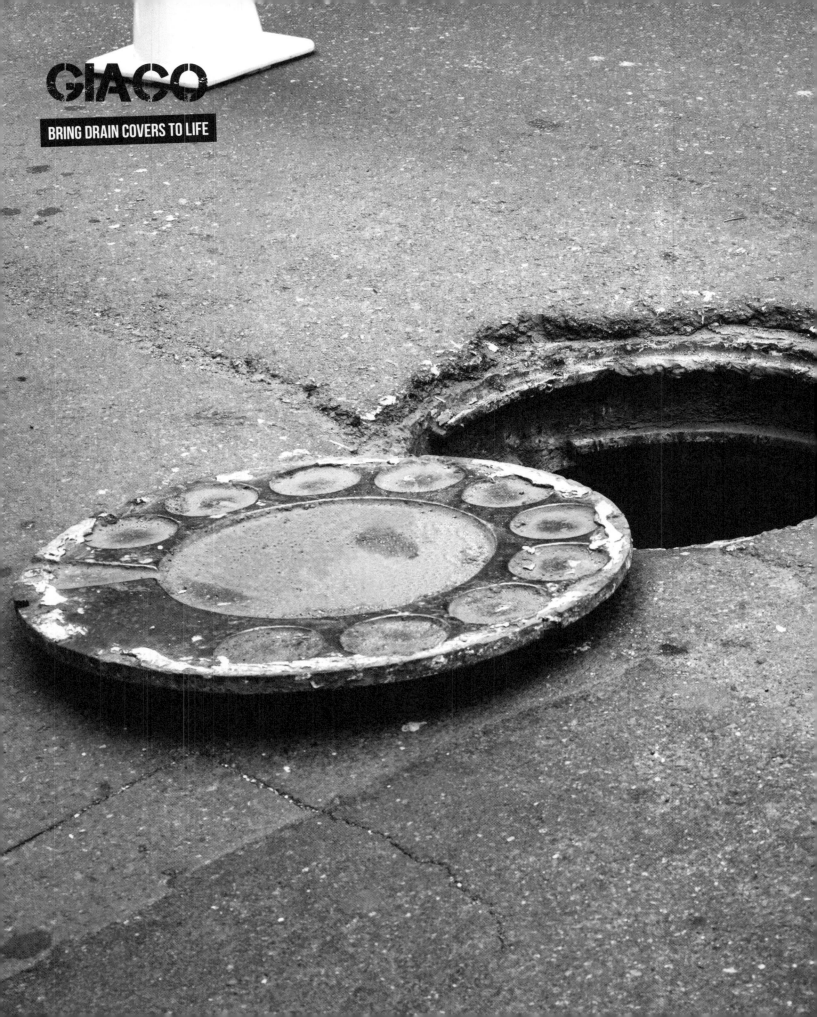

GIAGO

BRING DRAIN COVERS TO LIFE

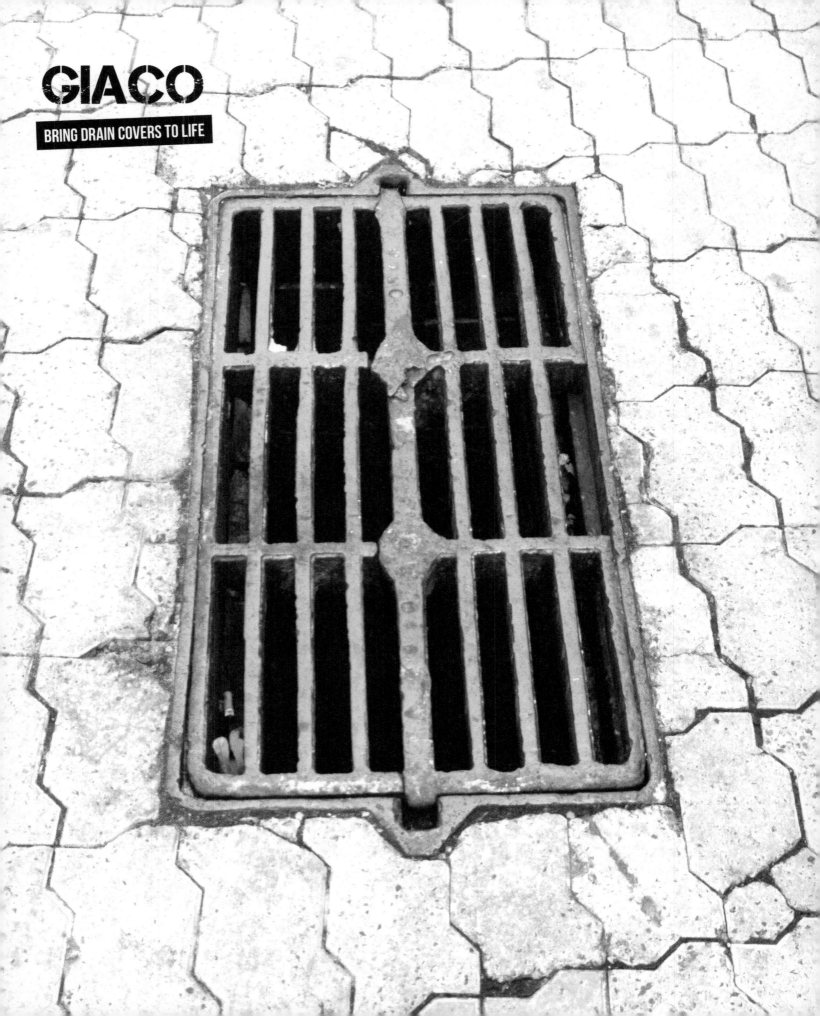

GIACO

BRING DRAIN COVERS TO LIFE

GIACO

BRING DRAIN COVERS TO LIFE

ROADSWORTH

"THE STREETS ARE DEMOCRACY'S TRUE BATTLEGROUND," says the Canadian Peter Gibson, AKA Roadsworth. "I regard street art as an alternative medium. Public space is a highly politicized arena, hotly fought over – especially in recent years, thanks to the increasing presence of brands." Roadsworth made his first appearance on the streets in 2001. At the time, he felt that the city of Montreal, where he lives, didn't have enough cycle tracks. He wanted to bring back some of the humanity that seemed to have been driven out of a world dominated by automobiles. So he painted the bicycles he was campaigning for on the ground, as a sort of rebellion against a certain kind of urban environment. "I think most cities have been designed to discourage play and creativity, which are sacrificed to the demands of functionality and security. I wanted to challenge this state of affairs. For me, cycling, like skateboarding, is a means of transport that is conducive to creativity – in contrast to the automobile, which is cut off from social interaction."

However, his project soon broadened in scope. Roadsworth developed a rich artistic language on the tarmac, combining humour and dreams. He transformed pedestrian crossings with painted footprints, road signs with electrical sockets, and parking spaces with images of dandelions. He covered areas of ground with skeins of wild geese and sandbanks. "I've always been attracted to the language of the road," he says. "The impersonal nature of road markings symbolizes modern life, which is often disembodied, within post-industrial capitalist society. This is fertile ground for visual satire, and maybe for a kind of poetry."

This poetry draws on the sterility of the place, its dizzying emptiness. "For me, roads and their markings are a metaphor for a mentality that aims to prioritize efficiency above everything else but which, paradoxically, proves to be rather inefficient. Because it represents perpetual motion, it is a symptom of our collective restlessness, our physical and psychological inability to be at rest – which, in essence, is indistinguishable from a denial of the here and now and, therefore, of reality."

What is Roadsworth's goal? Simply to break free of automatism – art produced mechanically and without conscious intent – and to reinvent the relationship each of us has with our environment. "When you introduce unexpected elements into everyday reality – which is the very root of street art – you force the public to challenge aspects of modern life that are generally taken for granted. Public space is regulated by rigid structures that influence our behaviour. These need to be attacked if we are to become aware of just how much they dominate us." His activism got him arrested in 2004, which was a turning point for him. Since then, he has concentrated on studio work and on commissioned pieces of public art, such as enormous murals that have an impact on the everyday experience of passers-by. "Most of what I do today isn't what I'd call street art, because, for me, street art can't be other than illegal. But I hope that the spirit of urban activism has continued to influence my work."

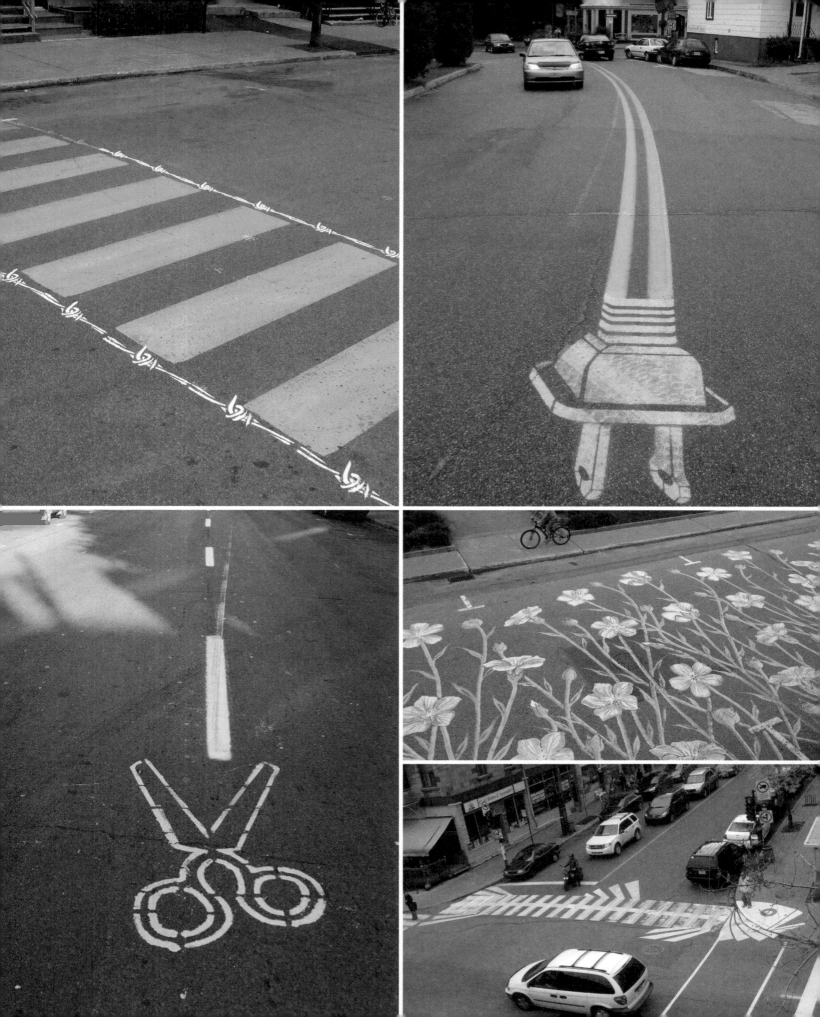

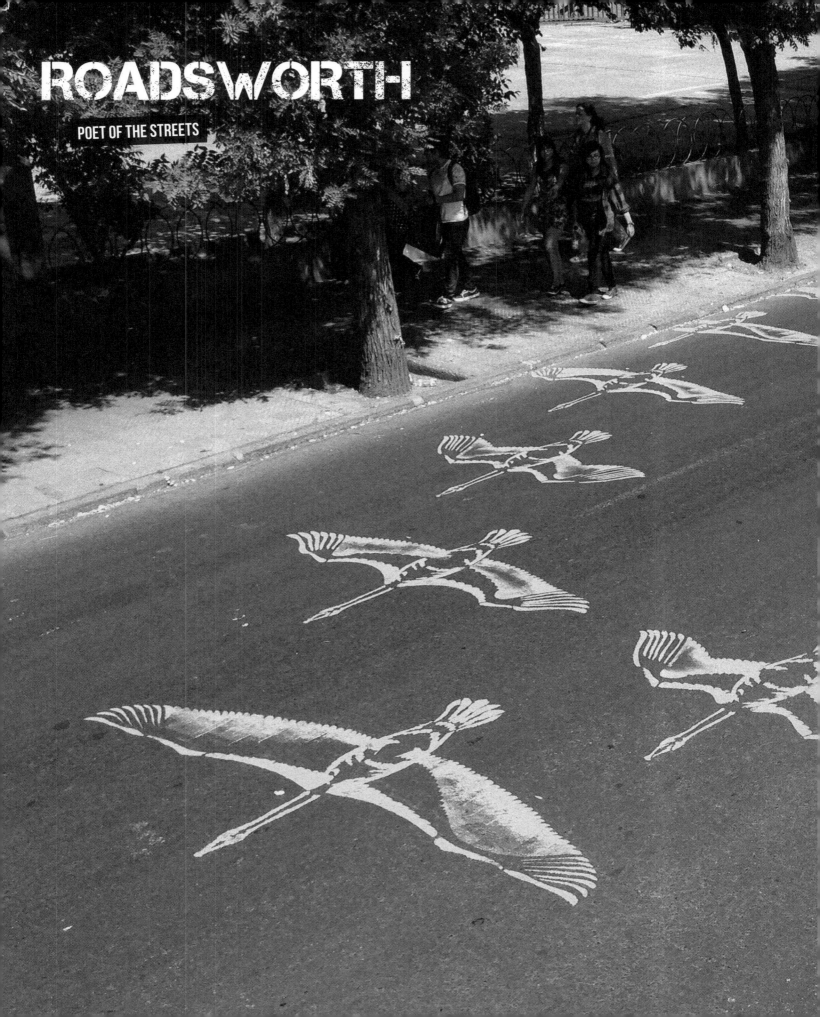

ROADSWORTH

POET OF THE STREETS

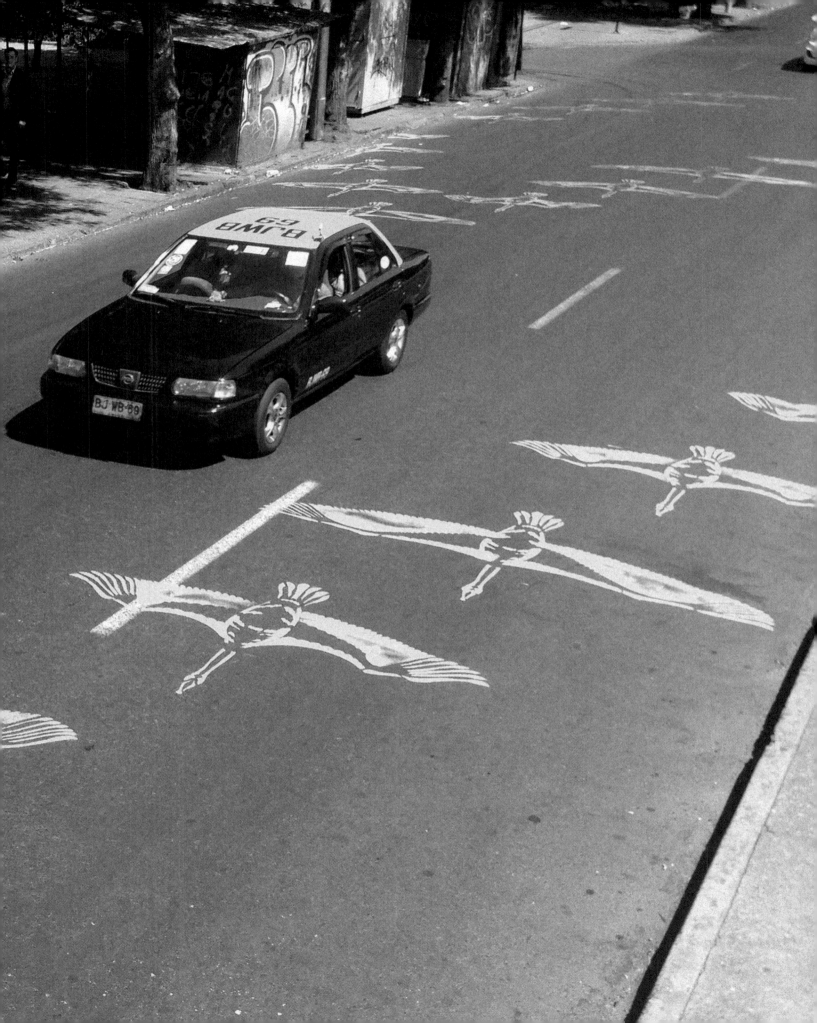

ROADSWORTH

BRING SOME POETRY TO THE STREETS

ROADSWORTH

BRING SOME POETRY TO THE STREETS

ROADSWORTH

BRING SOME POETRY TO THE STREETS

ROADSWORTH

ROADSWORTH

BRING SOME POETRY TO THE STREETS

CLET ABRAHAM

WRONG-WAY STREET

" I MAKE STREET SIGNS HUMAN!" says Clet Abraham defensively. His poetic, humorous collages have found their way into one-way streets and other thoroughfares the world over. It's the end of a long road. Born in 1966, he enjoyed a peaceful rural upbringing. His first encounter with the buzz of the city came when he moved to Rennes to study art. "After the starkness of the countryside, I was struck by the proliferation of signs, instructions, panels and so on," he recalls. Later, he went to Italy, where he settled first in Rome and then in Florence. He worked for a while as a furniture restorer, producing sculptures at the same time. But he was gripped by the desire to make it as an artist.

"I was 42 years old. I'd acquired the tools of the trade, but I didn't have a following, or a gallery. It seemed to me that at the very least I should have the chance to be judged by the public. Whether I made it or not, I just had to try!"

In 2010, he decided that the verdict would be reached on the streets of Florence. He embarked on a long-term campaign of redesigning signs, using pre-cut stickers. He also placed a statue on the embankment of the river Arno – a figure stepping out into the abyss, entitled *L'Homme du commun* ("Ordinary man"). For Clet, none of this was gratuitous. "I'm not against rules; every society needs them. But I want to put them in perspective. I'm not in favour of authority without discussion." His aim was to embody civic resistance, a healthy sense of rebellion and questioning. "Being a member of society doesn't mean obeying the law; it means showing solidarity."

For the sake of safety, he respects an object's function, making sure that his redesigns do not interfere with a sign's readability. This is part of the challenge, like expressing his ideas with simple shapes and the repetitive design of the signs he uses. In the museum-like city that is Florence, he creates mischievous designs without damaging the beauty of the place. His goal is to make passers-by smile. "Humour is a first, essential step towards communication." He hopes that his works are interactive. "I have a feeling that it's a group activity. My work, which is illegal, manages to survive thanks to the popular support it receives. We help each other. I am the voice of the people, and the people allow me to act." So much so that he tries to find common ground with a city's inhabitants by weaving into his pieces images of the icons of the cities in which he has worked, such as Michelangelo's David in Florence or the Eiffel Tower in Paris. "I am in favour of constructive activism. We must propose alternatives, and poetry is one of them." And the passion is there.

However, his work has divided the authorities. In recent years, Clet has received many public commissions and he has even run school workshops on road safety. But not everyone looks on him kindly: the city of Florence sealed off *L'Homme du commun* on the banks of the Arno – even though the locals liked it – and he has been fined a number of times. Worse, in 2015 his Japanese partner was investigated by the authorities and forbidden to leave her home country because she had helped him with his work in Tokyo and Osaka. The anxiety he went through inspired some new images, depicting escape. Protest can be a dangerous game.

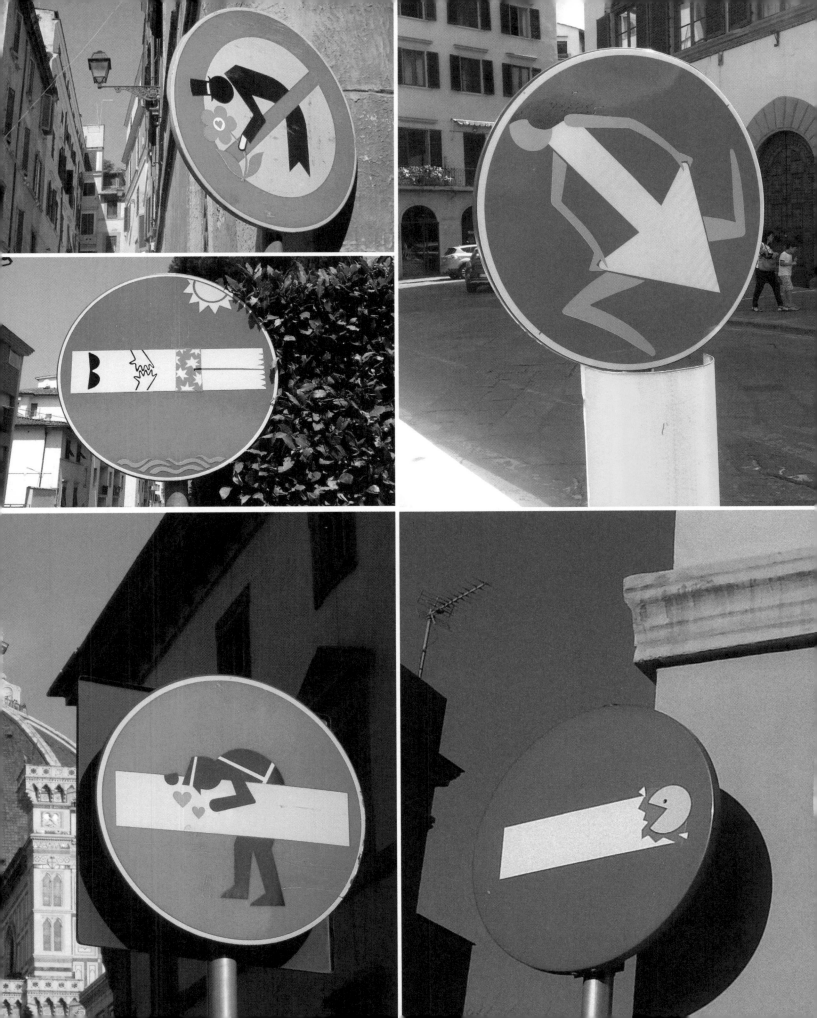

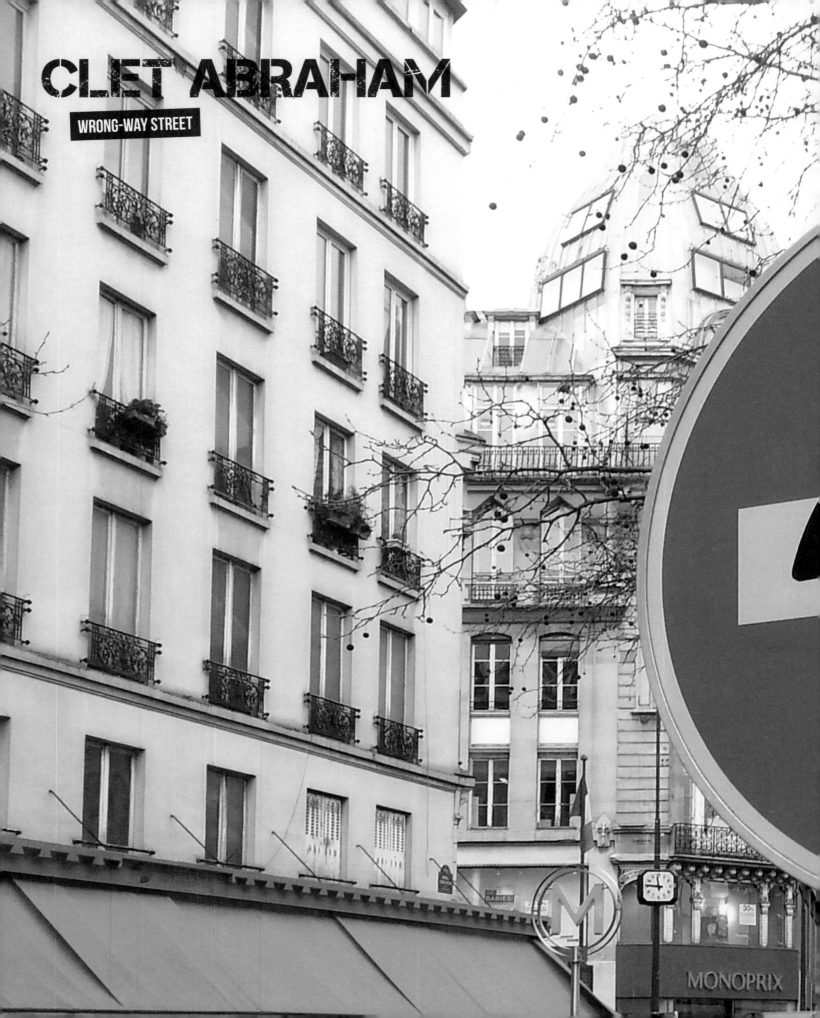

CLET ABRAHAM

WRONG-WAY STREET

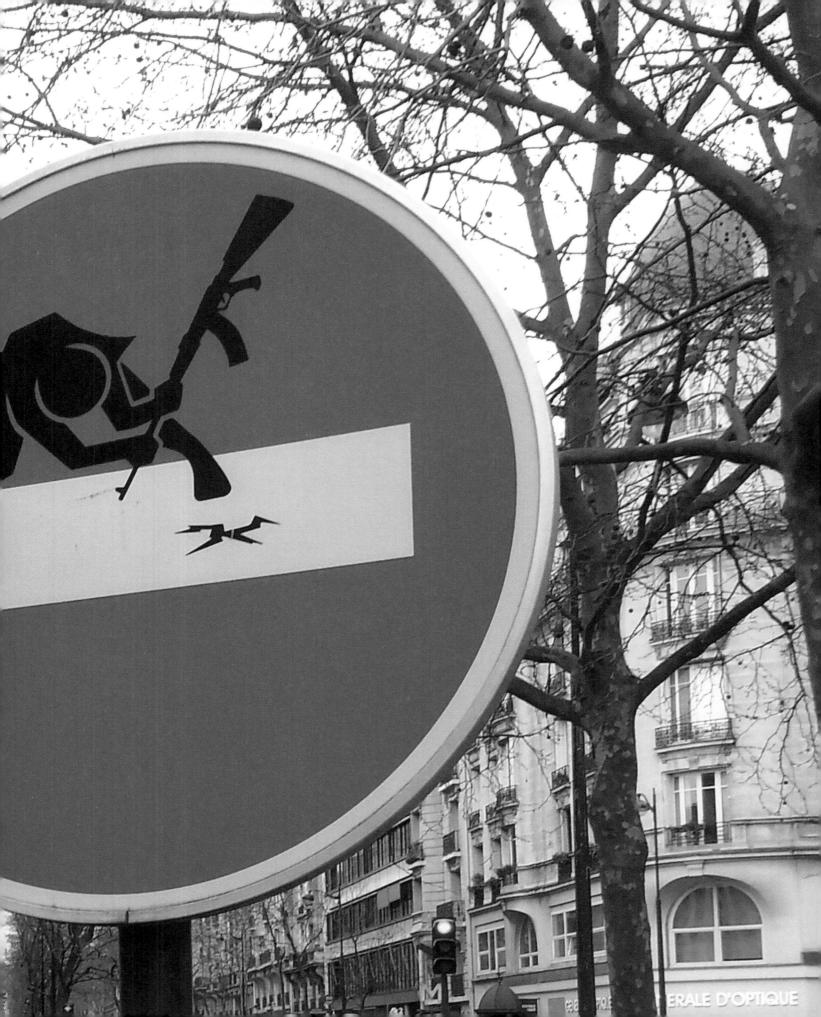

ERALE D'OPTIQUE

CLET ABRAHAM

CLET ABRAHAM

USE THE SIGNS AS YOUR CANVAS

CLET ABRAHAM

CLET ABRAHAM

USE THE SIGNS AS YOUR CANVAS

CLET ABRAHAM

USE THE SIGNS AS YOUR CANVAS

THE ART OF DIGRESSION

"PUTTING A NEW TWIST ON THE USUAL FUNCTION OF A CITY" is OX's goal. He positions his displays on – or in place of – adverts, offering a moment of light poetic relief. His creations play with the surrounding architecture, echoing the shapes and colours that are close to the advertisement hoarding, extending its space, or emphasizing it. "I disappear into the landscape, like a kind of camouflage," he explains. His love affair with advertising hoardings dates back almost 30 years, to when he was part of an artists' collective. At the time, the world of institutionalized art seemed closed. No problem – he and his associates decided to put posters up in the street. "We wanted to cut out the world of the galleries and be noticed by them at the same time."

The group disbanded in 1988, leaving OX feeling lost, to the point that he forgot about his beloved posters for several years. Eventually, though, he went back to them – gradually at first, then more regularly from the mid 2000s onwards. Little by little he developed a personal lexicon – a palette of bright colours, to attract the eye, and pared-down shapes, reduced to a geometric minimalism. "I hadn't done this with my first posters, but I soon realized that in the street, to be seen from a distance, you needed to simplify. I tried ever harder to retain just the essentials, until I found a language of my own."

He favoured waste or derelict sites, no man's lands on the edges of cities, building sites or characterless suburbs. "I'm interested in places you just pass through, that you don't stop to look at." He added an extra touch of strangeness by photographing his works, where possible, when the streets were deserted. In a world bursting with signs, he offers a breathing space, a digression. "I leave decorating and beautifying the city to others," he says. "What I want is to create an instant, often a very brief one." And to break people's habits by offering a new way of looking at things. "In the street, advertising creates a very utilitarian, familiar environment. When you come back after an artwork has been removed and advertising has been put back in its place, it feels as if you're looking at something much more banal." That said, he is not anti-advertising.

Humour lies at the heart of OX's work – he identifies strongly with the schoolboy provocativeness of the 1970s Bazooka collective and with the culture of satirical magazine *Hara-Kiri*, which he read in his youth. Popular imagery fascinates and inspires him. "When I was a kid, images were rare, except for television, which sneaked into our homes. You had to go and look for them: they weren't as easily accessible as they are today."

His posters, which are mostly hand-painted, bear witness to his love of accurate detailing and intricate craftsmanship. He may spend several years looking for the ideal site for an image, tirelessly scouting for locations, or lie in wait for hours by the side of an apparently soulless road for the truck that fits perfectly with the poster he has just put up. "It's strange, but this wait in such an uninteresting place has something thrilling about it," he says, smiling. What is at stake is the perfect photograph, one that seizes the ephemeral. "It matters to me that the instant has actually happened, that this isn't an image that's been manipulated on a computer." Redrawing the urban scene has fed into the art he produces in his workshop and into his recent exhibitions. "Thanks to my work in the street, I have dared to do things in the workshop that were unthinkable before." A school for freedom.

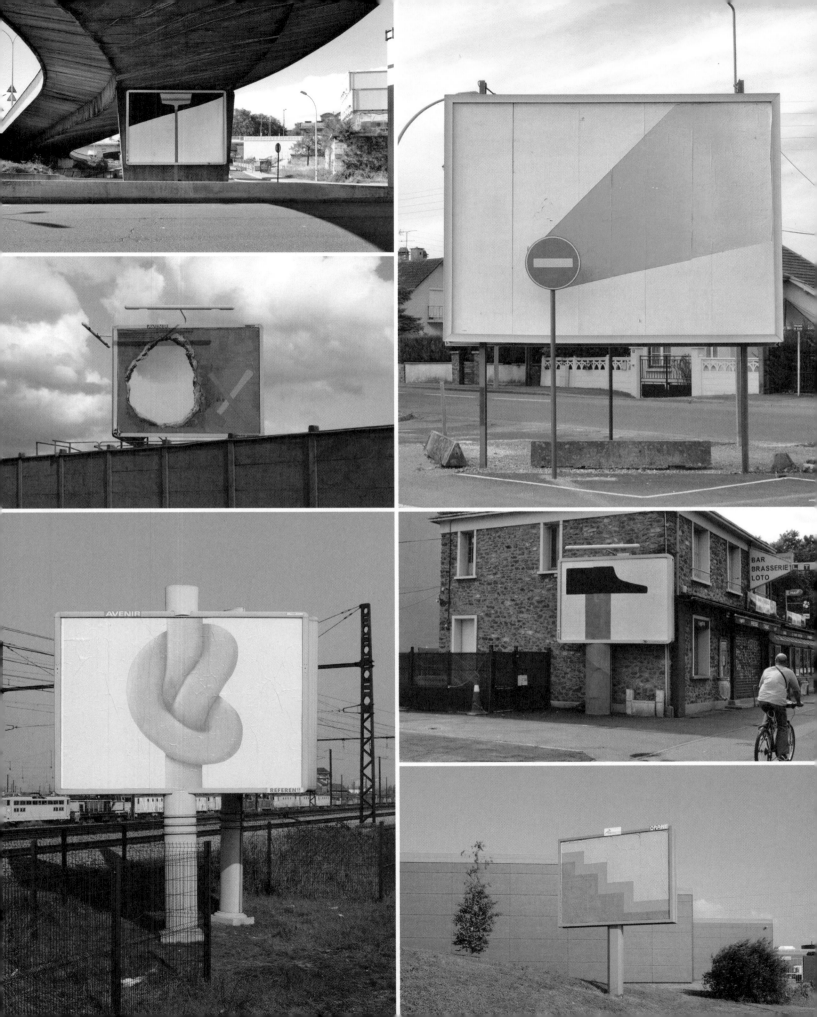

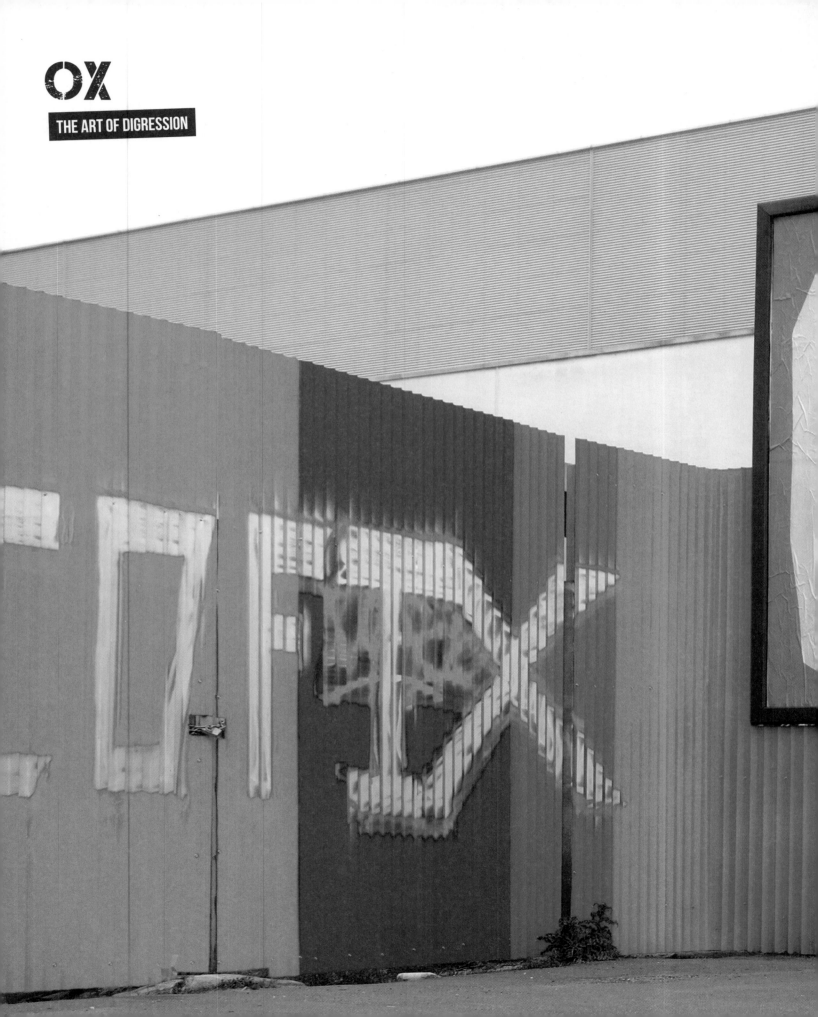

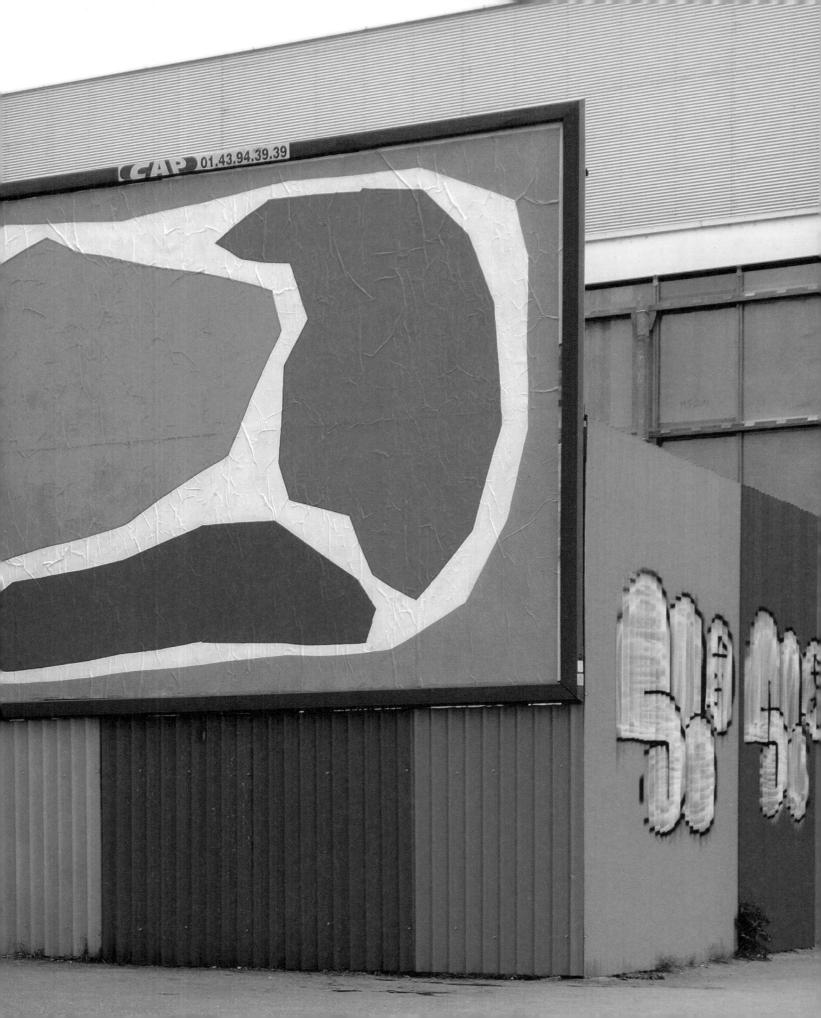

OX
CREATE YOUR OWN ADVERTS

LEVALET

CHARLIE CHAPLIN STYLE

A **MAN TUMBLES DOWN A STAIRCASE,** his fall broken into a series of stages depicted by as many dark silhouettes. Another man climbs the railings above a railway track. A couple clink glasses, curled up together in a hollow in a wall. Levalet's paper creatures disrupt the contours of the city with their black ink, exploring stories that crouch in hidden nooks.

Born in 1989, Levalet, who now teaches art with a special focus on shapes and volumes, started out working with video. He used to project images of characters onto buildings; like his collages today, this was a way of producing a clash between elements. "I feel that this reveals another dimension of the work, and can shatter the distance that may exist between the viewer and a pictorial image. When juxtaposed with a real place, the image becomes slightly ambiguous; it's seen as an integral part of the environment."

Levalet has also worked with improvisational theatre, and sees entering an urban space as a similar experiment: aiming to create an immediate scenario within a given set of constraints. "A particular element catches my imagination and, from this starting point, I create a story." He works according to self-imposed rules, such as drawing his characters life-size. "I have this desire – and I may just be deluding myself – to produce forms that, at first sight, appear human. It creates a sort of empathy between the viewer and the artwork..." he says. Empathy, yes, but also humour. Levalet plays with the idea of the visual gag, and flirts with the spirit of slapstick cinema, in the same way as video artist Pierrick Sorin, one of his acknowledged influences, does. "As in a silent film, I try to tell a story without words, using body language. I use very basic devices, such as you can see with Charlie Chaplin or Buster Keaton: a comic situation, gestures and so on."

As with these masters of the art, the comical does not rule out moments of melancholy, such as the men who seem to be dangling from a platform wedged in a wall. Isn't there a hint of cruelty at the heart of every gag, that indicator of human frailty? Levalet describes some of his works as "visual quips", especially those that hijack urban furniture, such as a fountain in the shape of a bull's head that he transforms into a Minotaur. He emphasizes this elegant humour by giving his collages titles. "Photography allows us to make the ephemeral lasting, and it crystallizes my work – it's the most incisive visual element. Even though the aspect that is most faithful to my work is actually being on site..."

Despite this, Levalet does not necessarily see himself as a street artist. "Street art is a label that doesn't always mean much, any more than other words that were invented to describe artistic movements, from cubism to abstract expressionism. These are categories, which do not always do justice to the individuality of an artist." An individuality that he has every intention of continuing to master.

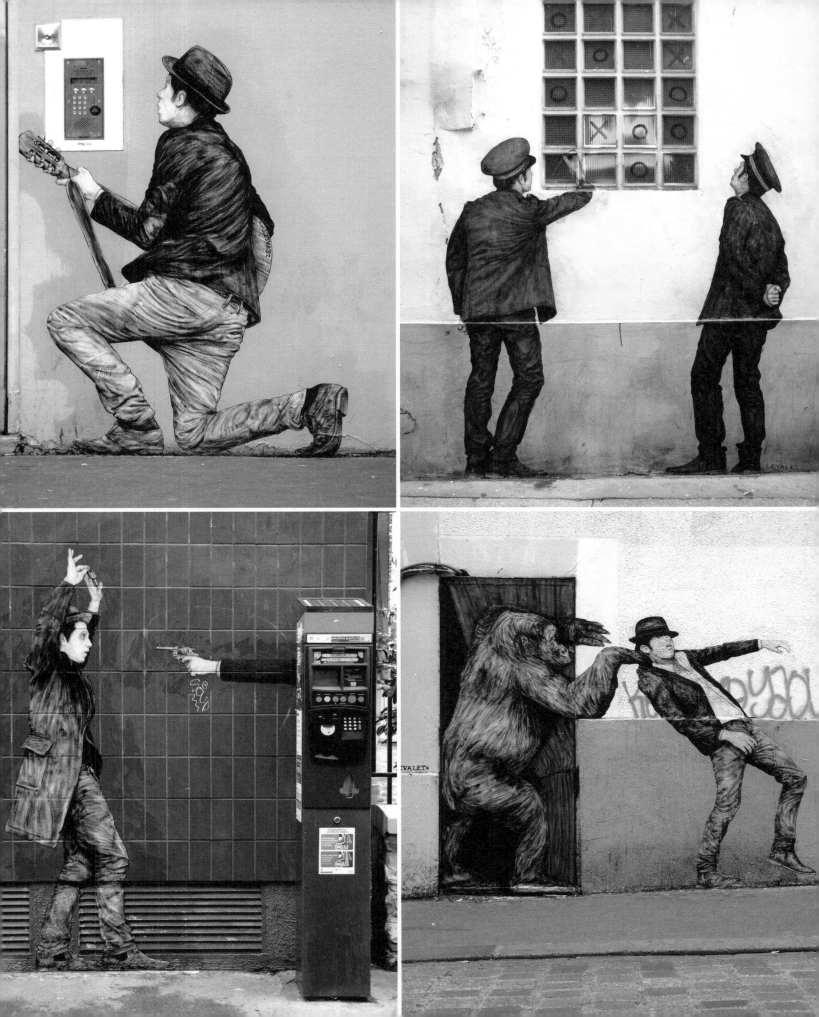

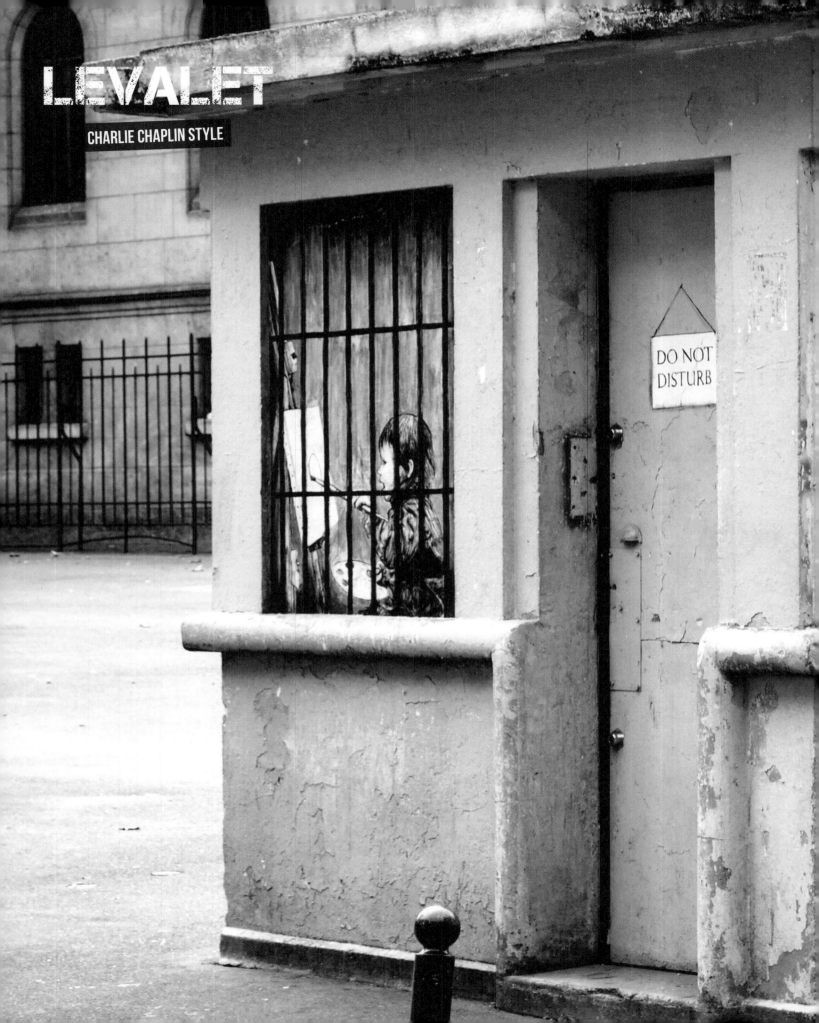

LEVALET

CHARLIE CHAPLIN STYLE

DO NOT
DISTURB

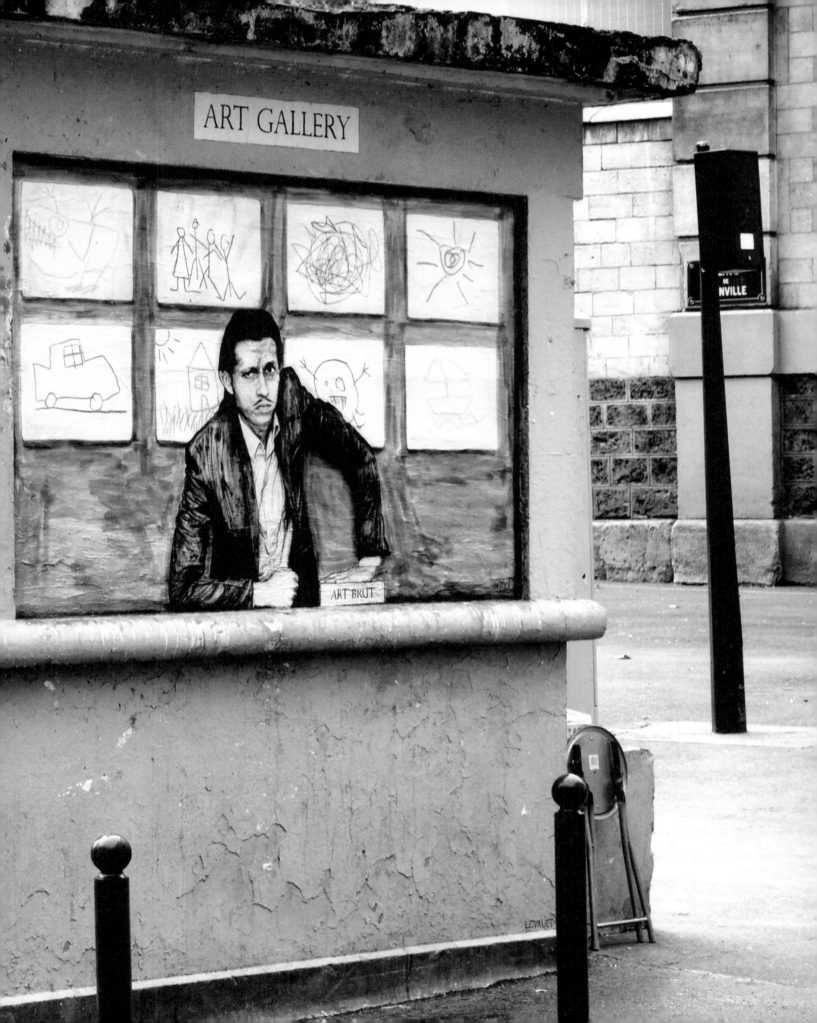

LEVALET

LEVALET

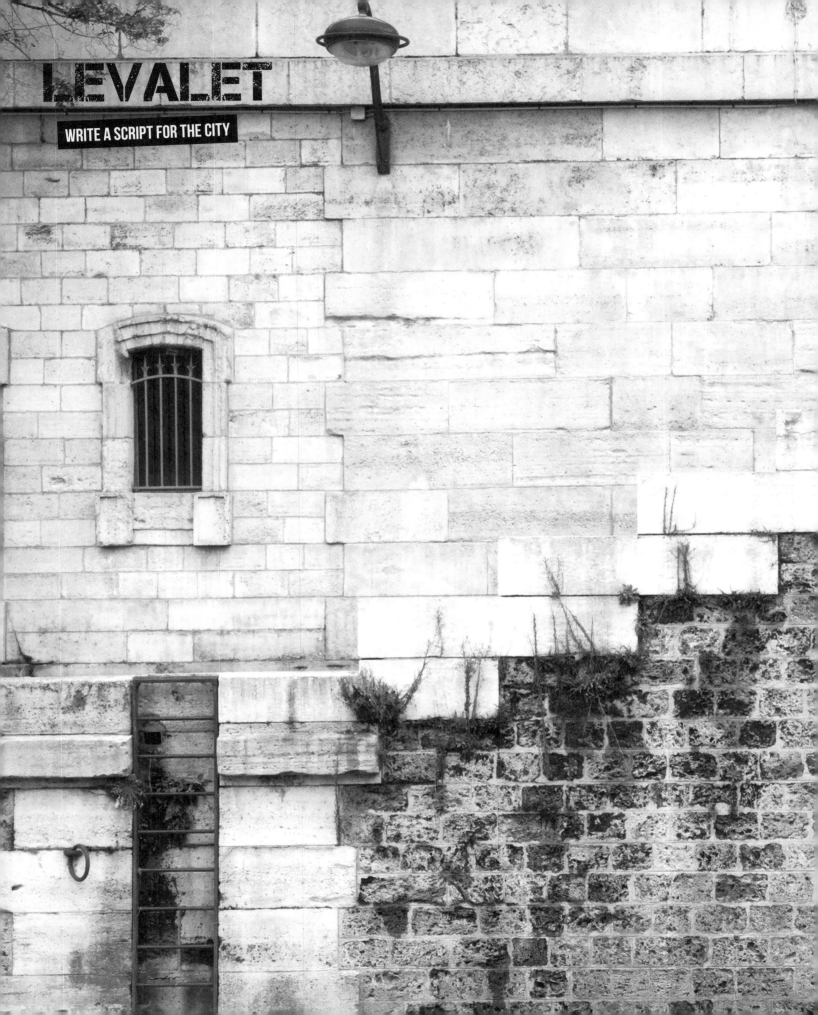

LEVALET

WRITE A SCRIPT FOR THE CITY

LEVALET

WRITE A SCRIPT FOR THE CITY

LEVALET

DAVID ZINN

WHEN PIGS FLY

HE WANTED TO BECOME A WRITER and took creative writing courses. Now, David Zinn tells his stories on street corners, armed with a few sticks of chalk. Despite being artistically adventurous (he has been an amateur opera singer and a presenter on children's radio, as well as reading to blind people), drawing is his most enduring passion. "Creatures drawn on the ground inhabit the real world, rather than existing only on a sheet of paper. In this way, my imaginary friends get closer to me." His chosen blank canvas is the town of Ann Arbor, Michigan. "It's small enough that I can cross it on foot in a day, and large enough that I still know only a fraction of it, even having lived there for 25 years. It offers an immense range of possibilities."

He adopted chalk as his medium in order to avoid over-seriousness. "Creating in public demystifies the artistic process, and brings down the barriers between the person drawing and the person watching. Chalk is cheap, so you don't need to skimp on using it, and there is something childlike about it, which reduces the need to produce serious art." As for his style, it's close to that of the children's books he grew up with. "I was brought up on Maurice Sendak and Mercer Mayer. Their illustrations encouraged me, later, to use monsters as a visual alternative to a strict portrayal of reality. When I was still very young I came across the illustrated poetry of Shel Silverstein and the drawings of Walt Kelly, both of whom showed me the seductive power of irreverent brats..."

David tells stories that don't necessarily have a beginning or an end: they are more like snapshots rich in narrative potential. He places small characters in front of elements of the urban landscape – benches, pavements, flowerpots – and creates *trompe-l'œil*, 3D effects. "When I was trying to become a writer, I was paralyzed by the multitude of choices that were needed to organize my thoughts, or simply to put one word after the other. When I draw on a pavement I don't have this problem, because I feel very much at ease letting the cracks and stains on the stones dictate what I ought to draw. I stare at the ground until I see something, and then I'm content to complete the missing pieces."

He has several characters that recur – some mice, a small green monster named Sluggo and a winged pig called Philomena. He likes to draw what comforts him – and will make others smile, bringing a bubble of light relief. His work is a miniature utopia, a gentle resistance against the order of things. The winged pigs allude to the expression "pigs might fly." And why not? "Drawing them is, to my mind, a way of saying that what we regard as impossible is sometimes merely rare." And the impossible happens: his creatures come to life – at least for those who are paying attention. "For a drawing to work, I must myself believe in the illusion, if only for a moment. My failed drawings are those where I've just gone through the motions of chalking lines on the ground, while the best are those with which I've been able to hold a conversation..."

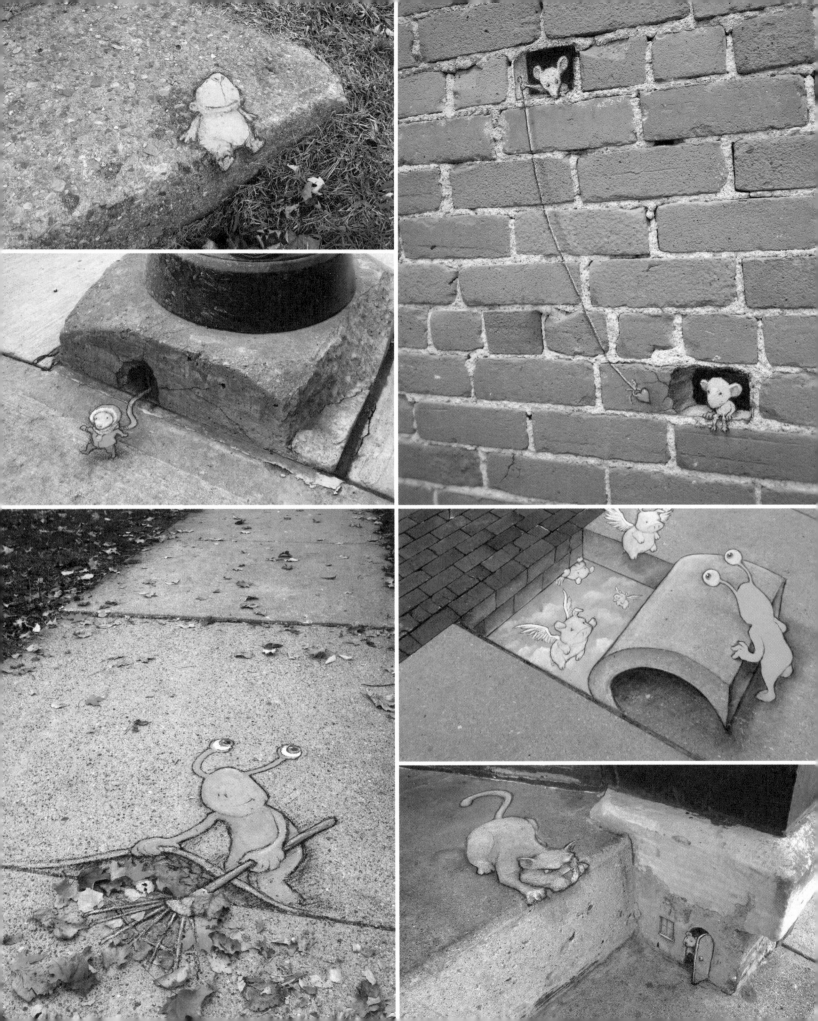

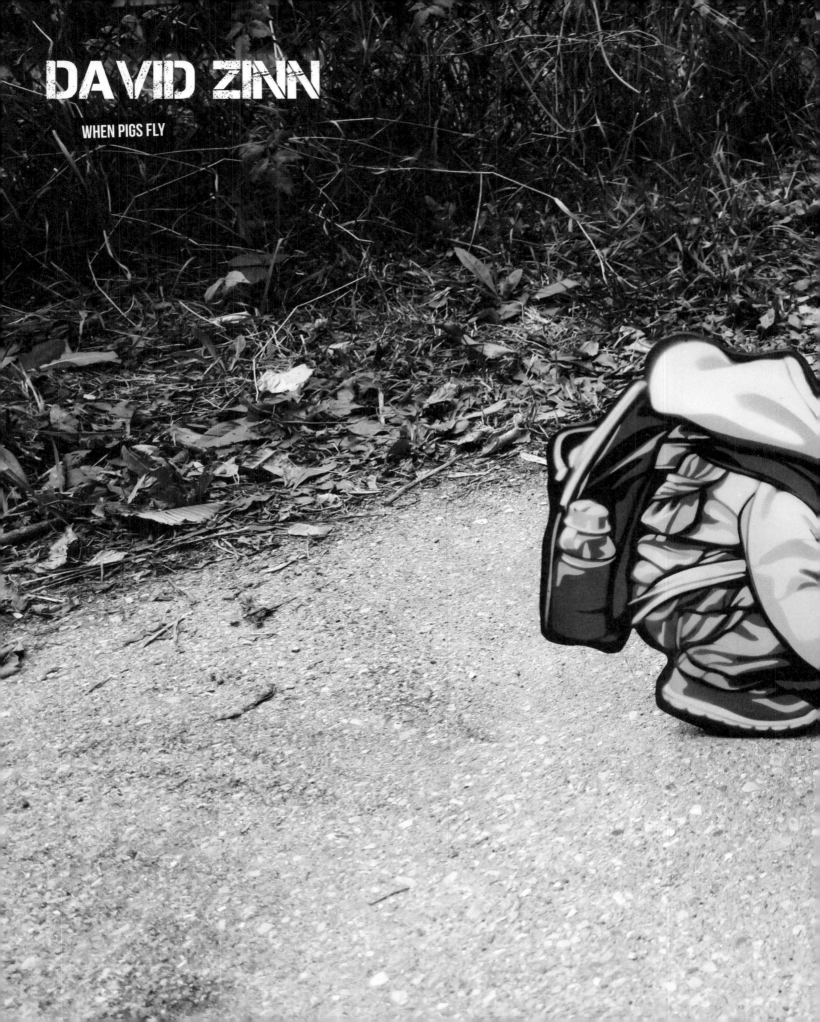

DAVID ZINN

WHEN PIGS FLY

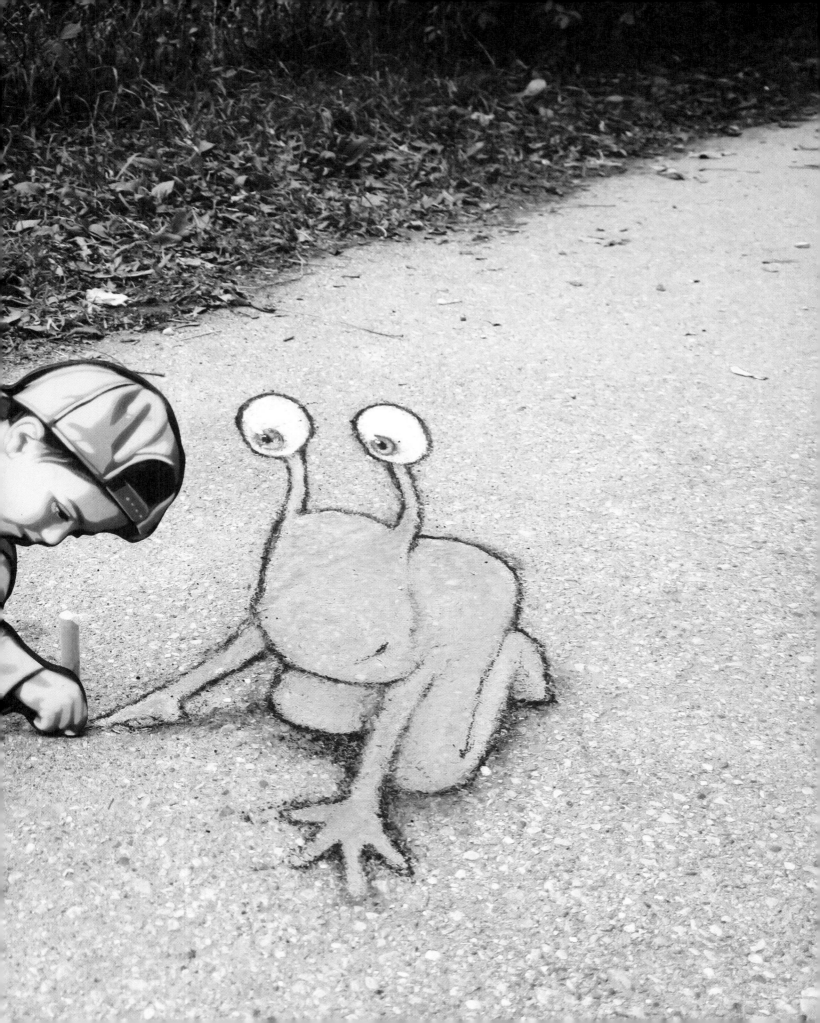

DAVID ZINN

CREATE YOUR OWN URBAN CHARACTERS

DAVID ZINN

CREATE YOUR OWN URBAN CHARACTERS

DAVID ZINN

CREATE YOUR OWN URBAN CHARACTERS

DAVID ZINN

CREATE YOUR OWN URBAN CHARACTERS

DAVID ZINN

CREATE YOUR OWN URBAN CHARACTERS

NIKITA NOMERZ

LISTENING FOR GHOSTS

HE AWAKENS THE SOULS OF SLEEPY **PLACES.** With a background in graffiti, the Russian Nikita Nomerz gives a face and an expressive gaze to abandoned buildings. Ten years ago, he embarked on a vast, long-term project entitled *Living Walls*. "I think each thing has its own face and its own character – houses especially. They retain the energy and history that have built up in them over the years." Nikita wants to bring out this hidden dimension, preferably in isolated, neglected premises. "I like to use each element of the architecture to show people what I see. I feel good in all sorts of abandoned, unknown places: I find them peaceful, and full of that urban energy that creates the ideal atmosphere for my work."

His home town of Nizhni Novgorod isn't short of either ghosts or isolated spots. "At the confluence of Russia's two greatest rivers, the Oka and the Volga, it's a zone of contrasts, where you can find both modern buildings and old wooden ones, some wonderful courtyards that everyone has forgotten, and some lovely people..." So Nikita wanders along the city's margins and through its dubious places. "One of the street artist's goals is to fill urban emptiness. I like to walk in search of interesting buildings, and return to them later if I decide I'm able – that is, if I think I can bring something new to them." In these spaces, nature is often in evidence. Nikita integrates it into his search for the spirit of a place, playing with nearby trees or rivers. "Street art is a dialogue – with architecture, with nature, with passers-by who will be its audience and with the authorities and the law. In the final analysis, it's a dialogue with yourself. That is its strength."

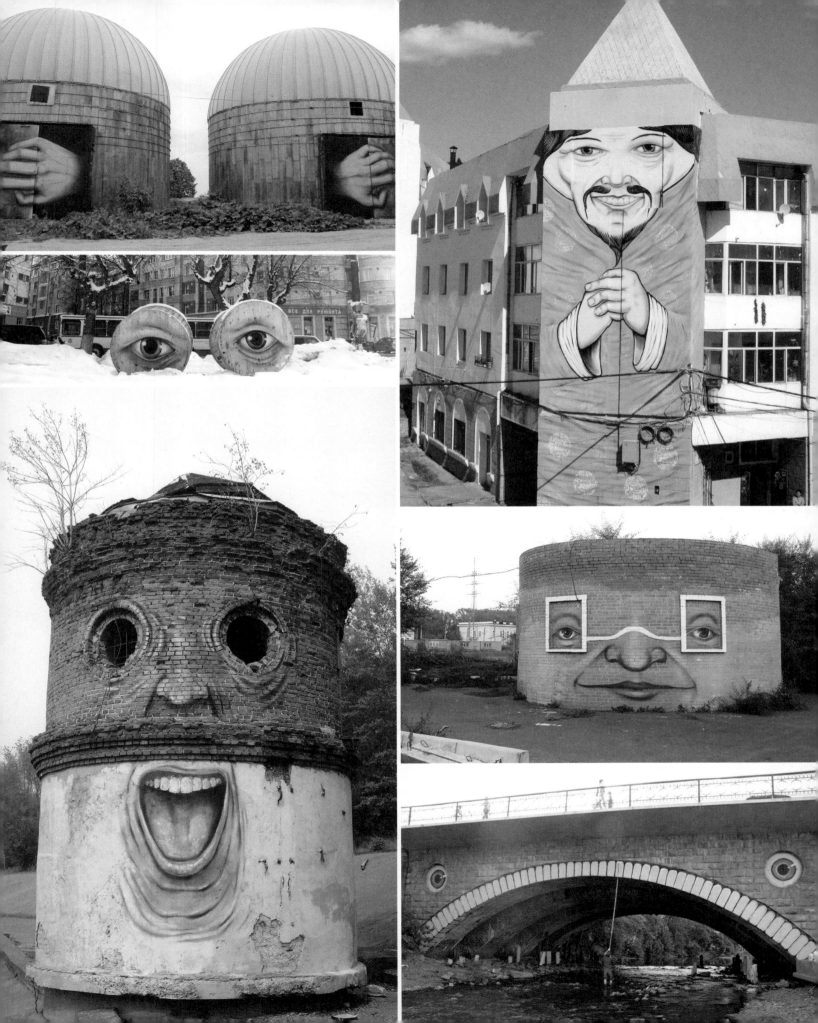

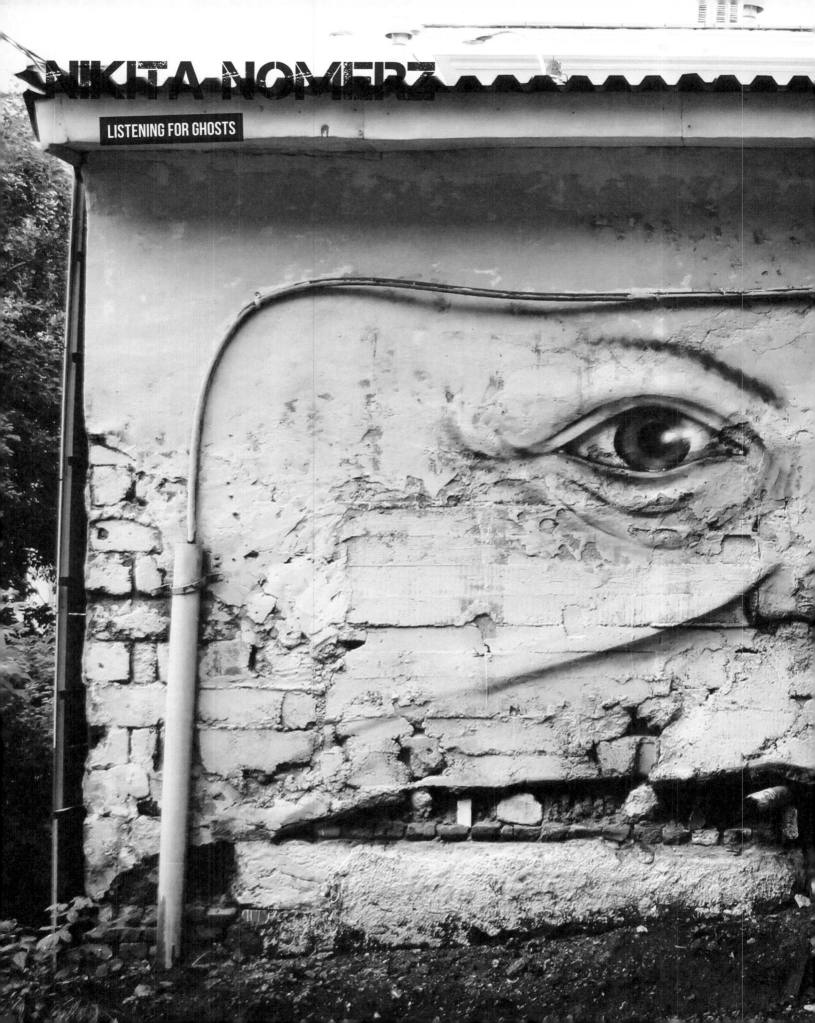

LISTENING FOR GHOSTS

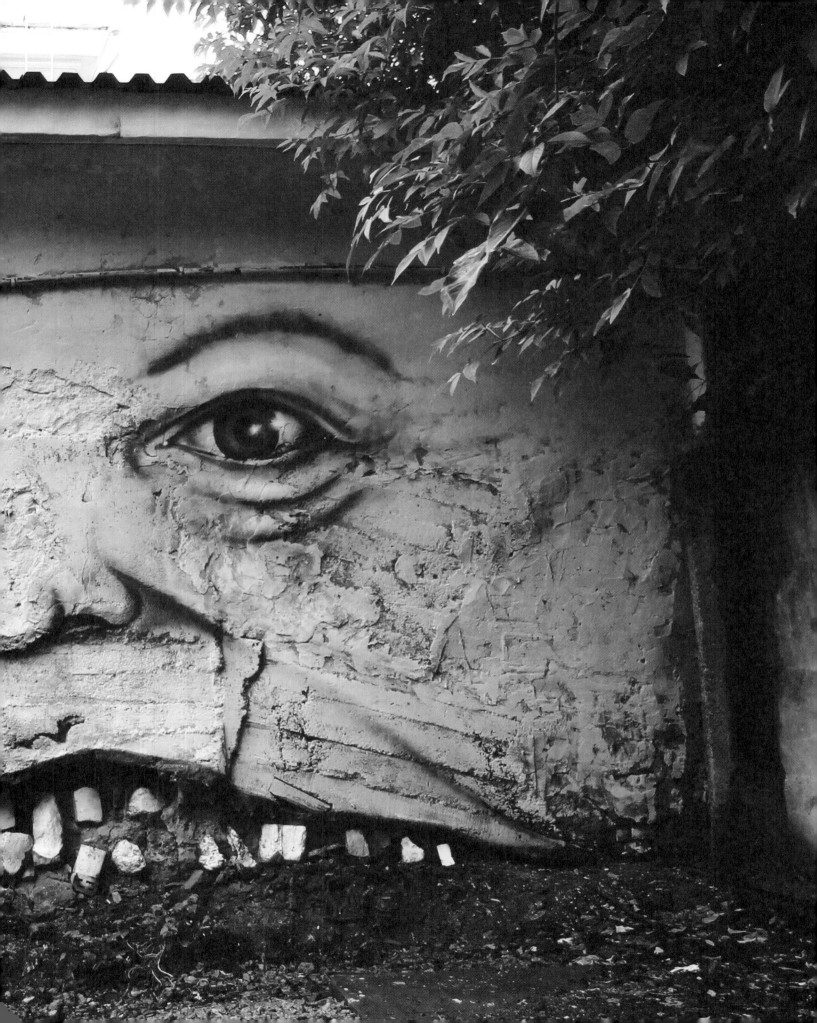

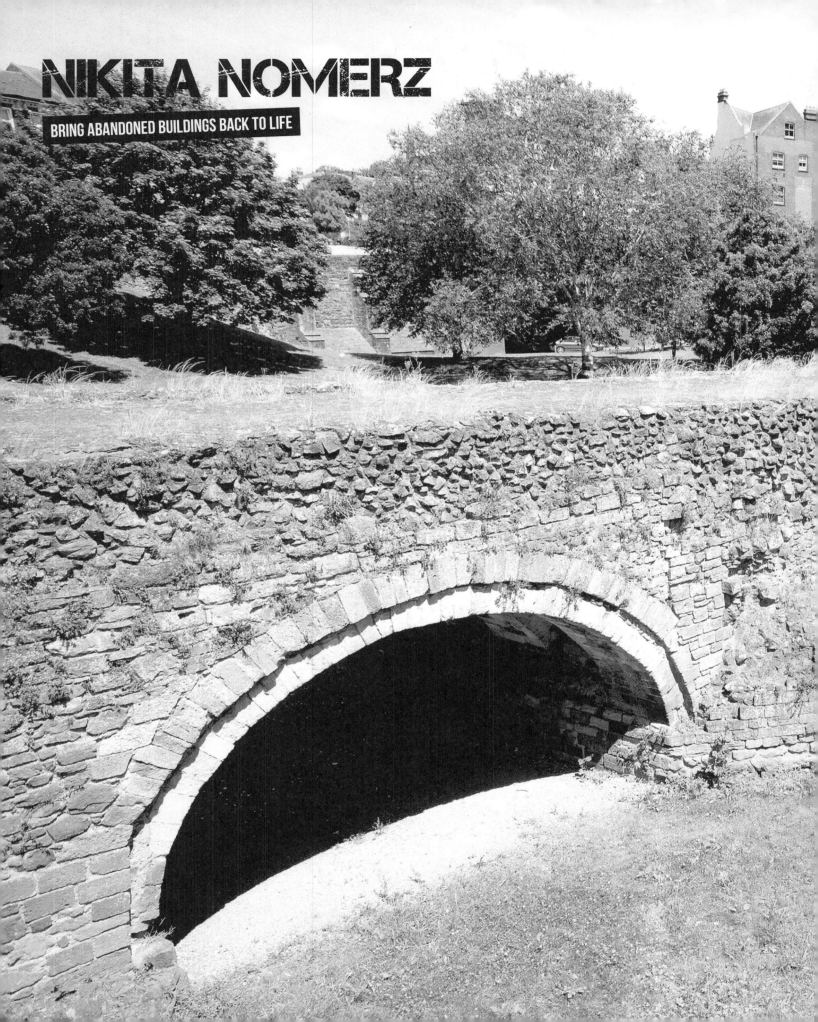

NIKITA NOMERZ

NIKITA NOMERZ

BRING ABANDONED BUILDINGS BACK TO LIFE

NIKITA NOMERZ

BRING ABANDONED BUILDINGS BACK TO LIFE

NIKITA NOMERZ

BRING ABANDONED BUILDINGS BACK TO LIFE

NIKITA NOMERZ

JORDANE SAGET

LINES OF CONVERGENCE

I'M QUITE SHY. I am not an adrenalin junkie," declares Jordane Saget. "To draw in the street, I needed to find the nerve!" Perhaps it is this sensitivity and reserve that made him want to create with chalk. "I didn't want to be a nuisance, or for anyone to feel attacked by what I was doing. With chalk, all you need is a bit of water to get rid of it." On pavements, doors, street furniture and drain covers, he demonstrates his virtuosity by tracing skilful arabesques, using a pattern of three parallel lines – a concept he developed during a period of isolation that followed a burn-out, and first tried out on paper. "I've been scribbling since I was a child, and I've always sought a design with a basic rule, which would allow me to be borne along. When these three lines appeared, it was as if I'd found what I'd been looking for ever since I was little..." He uses these lines to re-invent space, seeking the greatest possible harmony. He strives to achieve the perfect movement, having practised t'ai chi ch'uan – a precisely choreographed martial art – for the past seven years.

In 2015 he took the plunge and transferred his lines to the streets. "I needed to get out once more, and take my lines with me – those lines that had helped me during that year when I wasn't well." Public space transformed his drawing. In the street, his movements acquired breadth, involving his whole body. The lines took on a moving, hypnotic energy. "They are almost alive. I call them micro-organisms. They remind me of the structure of DNA: my lines, which can seem similar, are in fact all different." They also bring to mind waves or blossom – an invisible, gushing power. They play more on variation than repetition. "Every time I draw a line, I question everything," continues Jordane, who takes great care over the decoration of his installations, though he puts them in places where chance takes him. "I allow myself to feel where I need to go. Often, I follow the sun. And there comes a moment when it's obvious."

Jordane also had the opportunity to gently make his mark in Paris. "When I arrived in Paris, I was 15 and I disliked it for a long time. I came from Fontainebleau, which is famous for its forest, and I resented Paris because it didn't have my forest. But when I started working with chalk, I began to see the city's beauty." To the point that he began to play with some of its iconic elements: its Wallace drinking-fountains, the pyramid of the Louvre, Buren's columns at the Palais Royal and so on. One of his finds was the understated rue de Furstenberg on the Left Bank. "Art Deco interests me a lot. My lines enhance it, and vice versa."

Jordane experiments with various surfaces. He has a weakness for the frames offered by empty advertising spaces on the Paris Métro and the labyrinthine network of corridors linking two stations – even though he has been fined for working in such places. He likes chalk's mineral quality, and its ability to stick to a surface and catch the light.

It took him just a few months to realize how much enthusiasm his works aroused. "That helped me to come out of my shell," he continues. "Some people found my lines soothing, and told me so. I was touched by that. So much so that I'm convinced there is a thread that connects us one to the other, and that my lines make this thread appear." The morning after the Paris terrorist attacks of November 2015, he was in Place de la République, disorientated and feeling at rock bottom. He decided to get out his chalks. Some people watched him; he proffered sticks of chalk to them, and left a pile for people to pick up. "Within half an hour, 300 people had passed by, and our fresco was 25 metres (82 feet) long! That was a very powerful moment."

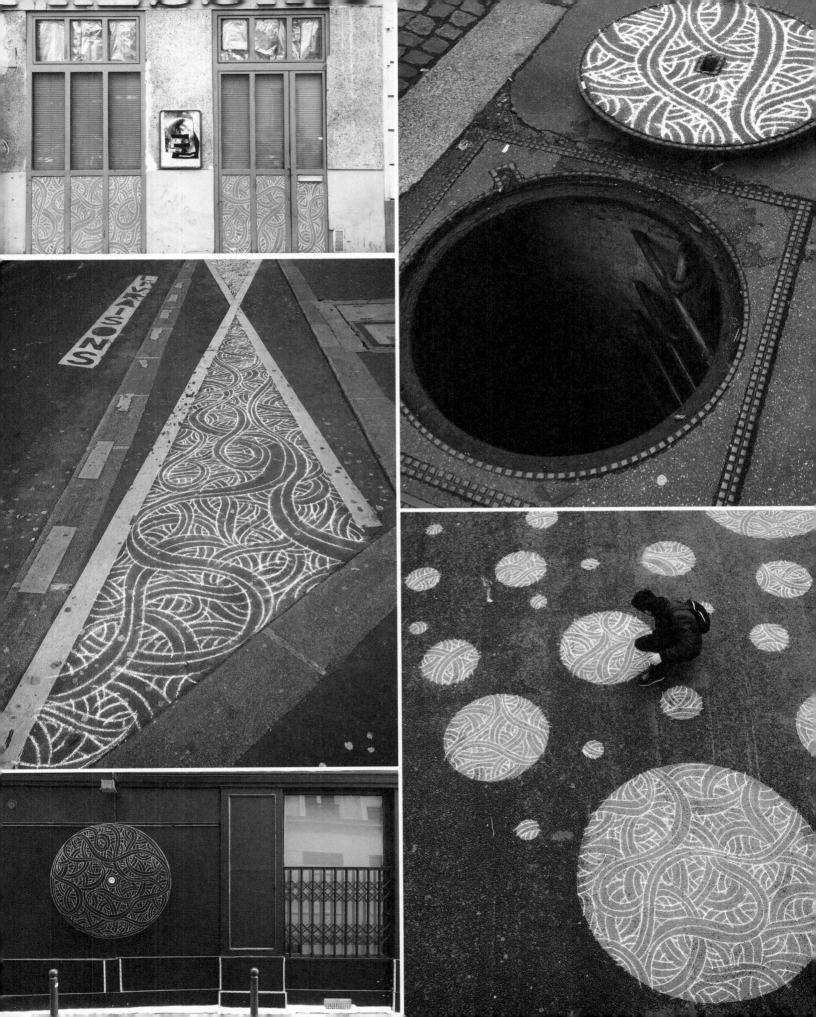

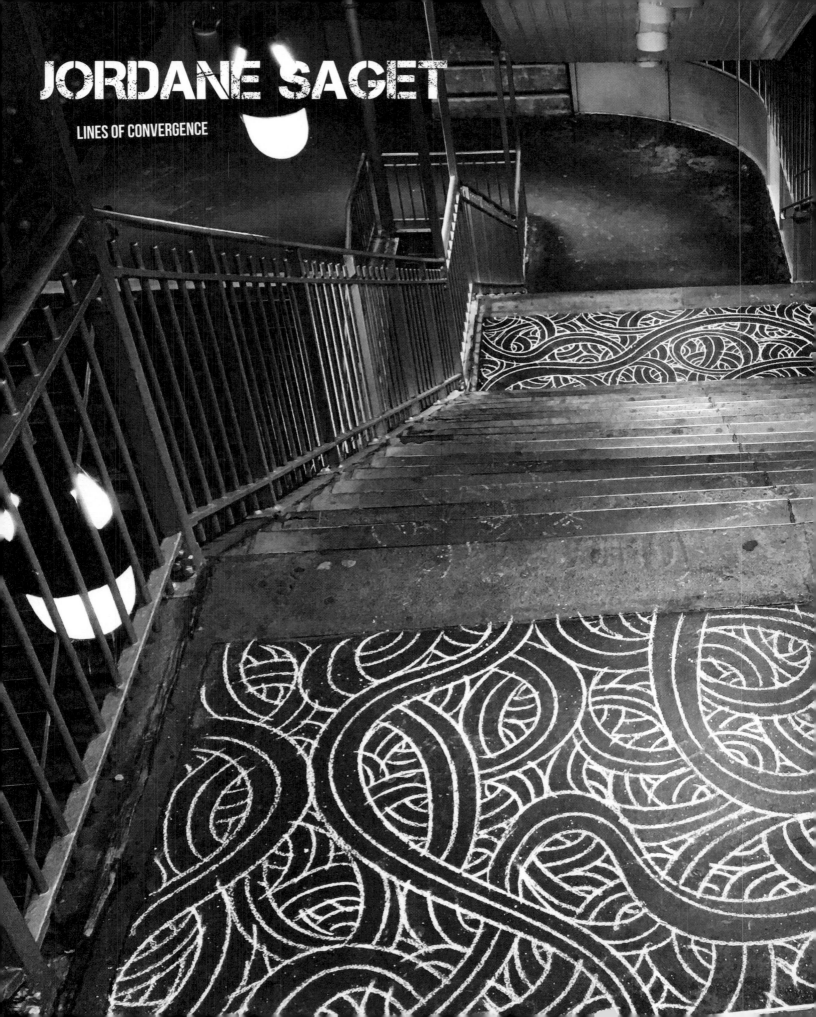

JORDANE SAGET

LINES OF CONVERGENCE

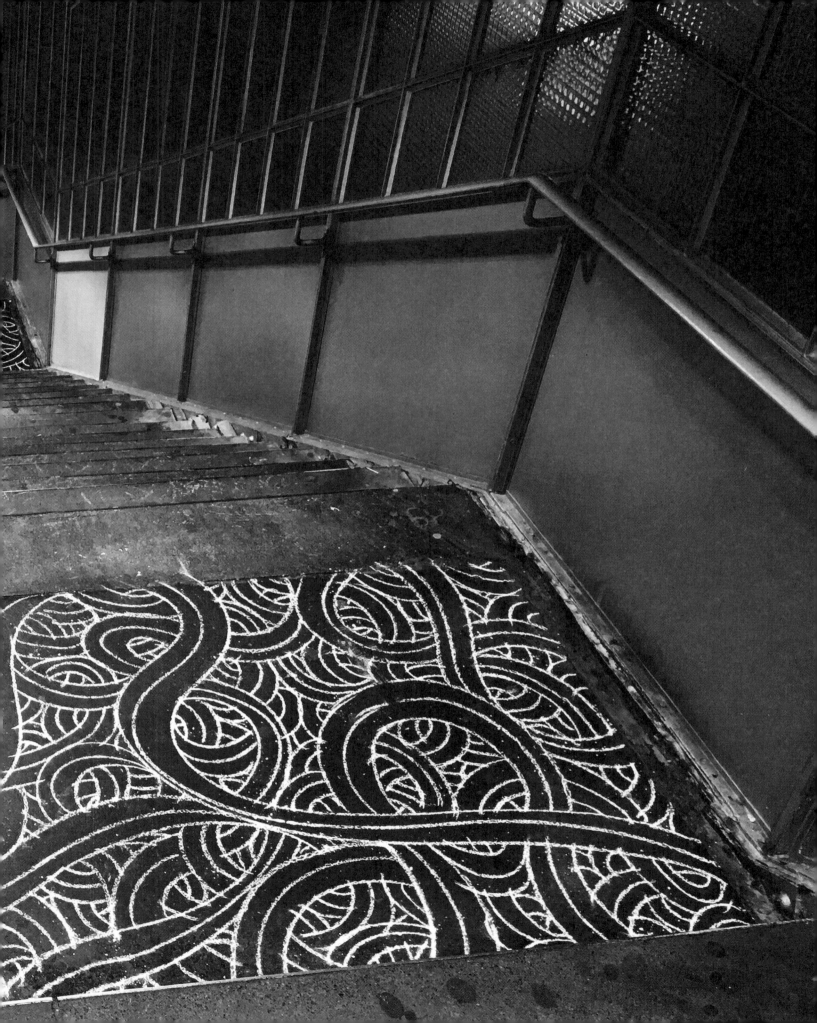

JORDANE SAGET

DRAW SOME HYPNOTIC LINES

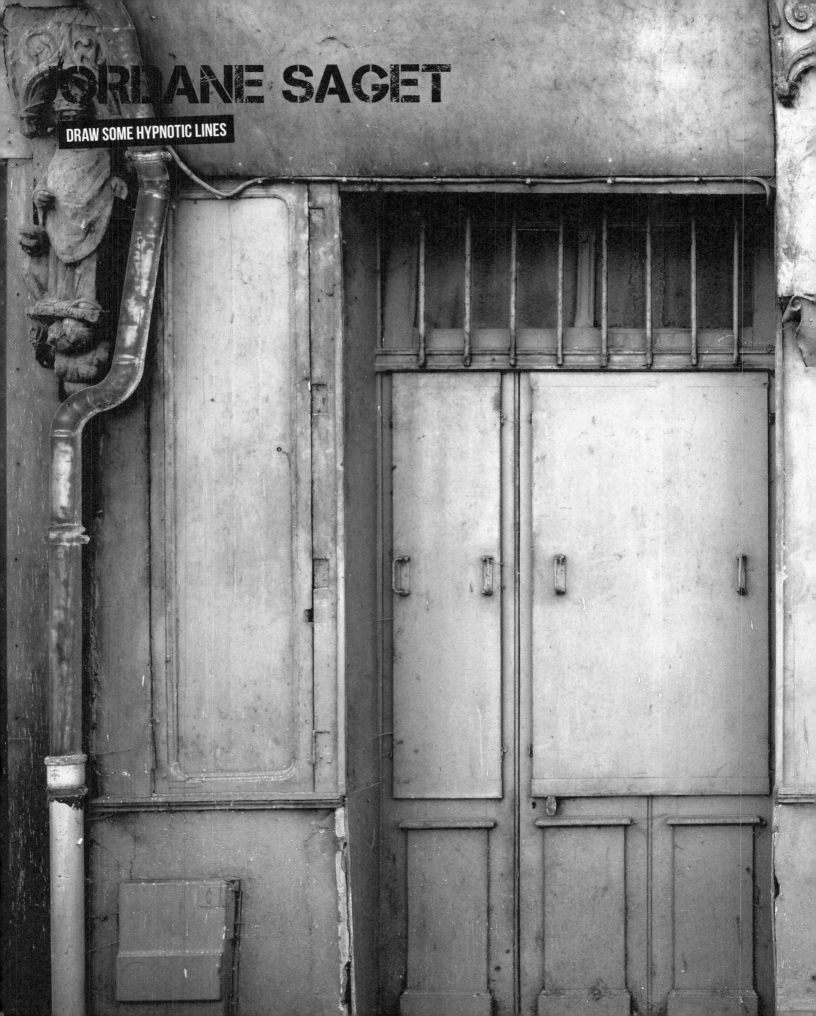

JORDANE SAGET

DRAW SOME HYPNOTIC LINES

JORDANE SAGET

DRAW SOME HYPNOTIC LINES

JORDANE SAGET

DRAW SOME HYPNOTIC LINES

JORDANE SAGET

DRAW SOME HYPNOTIC LINES

JORDANE SAGET

DRAW SOME HYPNOTIC LINES

JORDANE SAGET

DRAW SOME HYPNOTIC LINES

CRÉDITS

OAK OAK
P7-9 © Oak Oak • P10 ©iStock/Christopher Steer • P11 ©iStock/wepix
P12-13 ©iStock/2nix • P14 ©iStock/Eureka_89 • P15 ©iStock/bignoze
P16-17 ©Fotolia/zephyr_p • P18-19 ©iStock/Francesco Scatena
P20 ©iStock/Wouter van Caspel • P21 ©iStock/Jitalia17

LE CyKLOP
P23-25 © LE CyKLOP/ADAGP • P26-29 ©HelloElo • P30 ©iStock/Kilav
P31 ©iStock/Alan_P • P32-33 ©iStock/ilbusca • P34-35 ©HelloElo
P36 ©Fotolia/imfotograf • P37 ©Fotolia/Vinoverde

GIACO
P39-41 © Giaco • P42 ©Fotolia/gabort • P43 ©Fotolia/aanaon
P44 ©iStock/bitlaurent • P45 ©Fotolia/Virynja • P46-47 ©iStock/Alfonso
Cacciola P48 ©iStock/bartosz_zakrzewski • P49 ©iStock/LdF • P50-51 ©iStock/Terex
P52 ©iStock/Straitel • P53 ©Fotolia/david734244 • P54-55 ©iStock/©
Nicola Stratford

ROADSWORTH
P57-59 ©Roadsworth • P60-61 ©Fotolia/torsakarin • P62 ©Fotolia/sergiy1975
P63 ©Fotolia/shocky • P64-65 ©Fotolia/sergiy1975 P66-67 ©Fotolia/
robsonphoto P68 ©Fotolia/robsonphoto • P69 ©Fotolia/robsonphoto
P70 ©iStock/mihailomilovanovic • P71 ©iStock/huseyintuncer
P72-73 ©iStock/huseyintuncer

CLET ABRAHAM
P75-77 © Clet Abraham • P78 ©Fotolia/tomaskocis P79 ©iStock/Evgeny Sergeev
P80-81 ©Fotolia/Glaser • P82 ©iStock/GavinD • P83 ©iStock/andrearoad • P84
©iStock/bravo1954 • P85 ©Fotolia/Ewald Fröch • P86-87 ©iStock/StockFinland
• P88 ©iStock/Evgeny Sergeev • P89 ©iStock/Evgeny Sergeev

OX
P91-93 © Ox • P94 ©Fotolia/casanowe • P95 ©Fotolia/Photomika • P96-97
©Fotolia/Photomika • P98-99 ©iStock/Tertman • P100-101 ©Fotolia/
anyaberkut • P102-103 ©iStock/ilbusca • P104-105 ©Fotolia/PixelThat

LEVALET
Cover and P107-109 © Levalet • P110-111 ©iStock/Green_beat • P112-113 ©iStock/
Wylius • P114-115 ©iStock/Evelin Elmest • P116-117 ©iStock/Alfonso Cacciola
P118-119 ©Fotolia/donatas1205 • P120 ©iStock/zorazhuang • P121 ©iStock/
tusumaru • P122-123 ©iStock/ran77th

DAVID ZINN
P125-127 © David Zinn • P128 ©Fotolia/miket • P129 ©iStock/George Clerk
P130-131 ©iStock/AnthonyRosenberg • P132-133 ©iStock/Veyla • P134 ©iStock/
fotolinchen • P135 ©iStock/MagMos • P136-137 ©iStock/NoDerog • P138-139
©Fotolia/hd-design

NIKITA NOMERZ
P141-143 © Nikita Nomerz • P144 ©Fotolia/full moon • P145 ©iStock/catcha
P146-147 ©Fotolia/tichr • P148 ©Fotolia/Igor Groshev • P149 ©Fotolia/
amadeoav P150 ©iStock/asterix0597 • P151 ©Fotolia/amadeoav • P152 ©iStock/
DanielPrudek • P153 ©iStock/futurewalk • P154-155 ©Fotolia/batya

JORDANE SAGET
P157-159 © Jordane Saget • P160-161 ©Fotolia/zhu difeng • P162-163 ©Fotolia/
Studio Photo AG • P 164-165 ©Fotolia/fabiomax • P166-167 ©iStock/Roberto A
Sanchez • P168 ©Fotolia/nd700 • P169 ©iStock/FooTToo • P170-171 ©Fotolia/
aytuncoylum • P172 ©Fotolia/Tree4Two • P173 ©iStock/acilo • P174-175
©Fotolia/mantinov

This edition
Text: Sophie Pujas
Commissioning Editor: Joe Cottington
Junior Editor: Ella Parsons
Senior Designer: Jaz Bahra
Translator: Simon Jones
Copyeditor: Caroline Taggart